MY AMERICA

For my Havana and Mathilda

MY AMERICA

CHRISTOPHER MORRIS

STEIDL

For 15 years I have been photographing wars around the world. After the birth
of my daughters I knew that I wanted a change. In the year 2000 I turned away
from wars and set out traveling across the United States documenting President
George W. Bush for TIME magazine.

What I discovered was a people in love with their country and their President,
a culture of American society that had found a "divine" Bush. *MY AMERICA*
is a chronicle of this journey.

–Christopher Morris 2005

E PLURIBUS UNUM
"OUT OF MANY ONE"

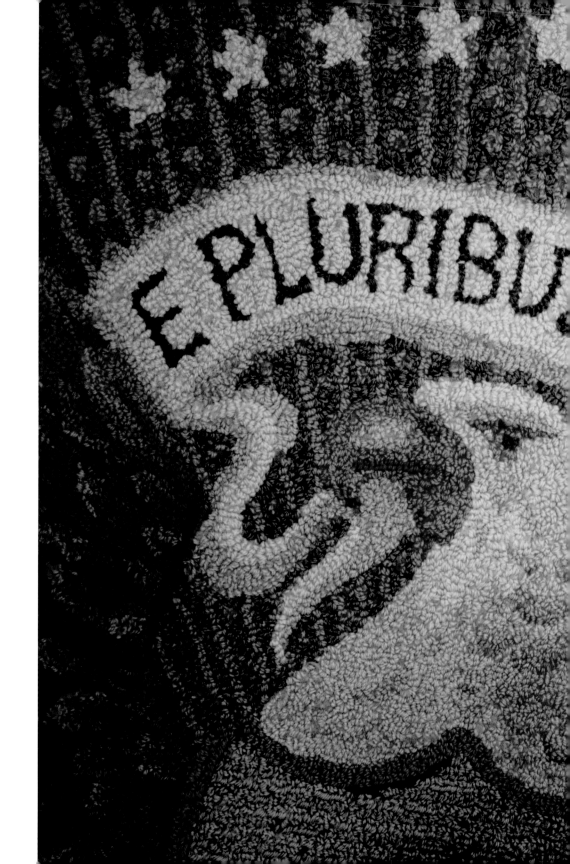

Washington, D.C. 2004

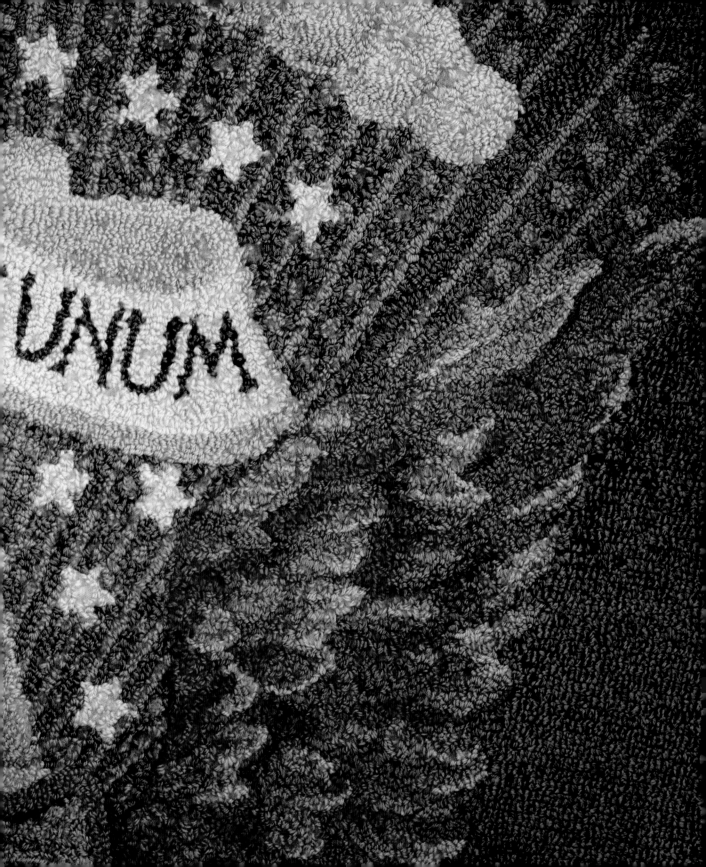

Wells, Maine 2004

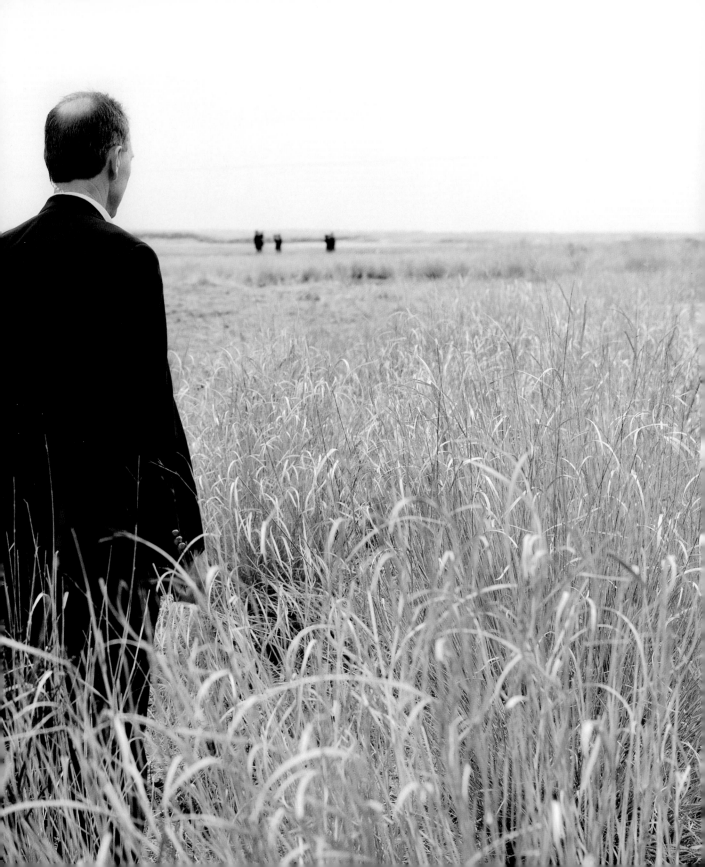

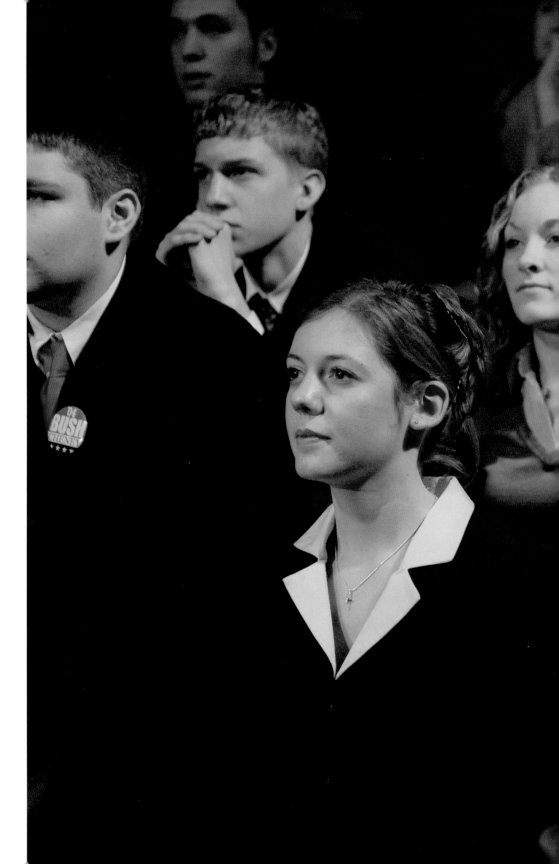

Harrisburg, Pennsylvania 2004

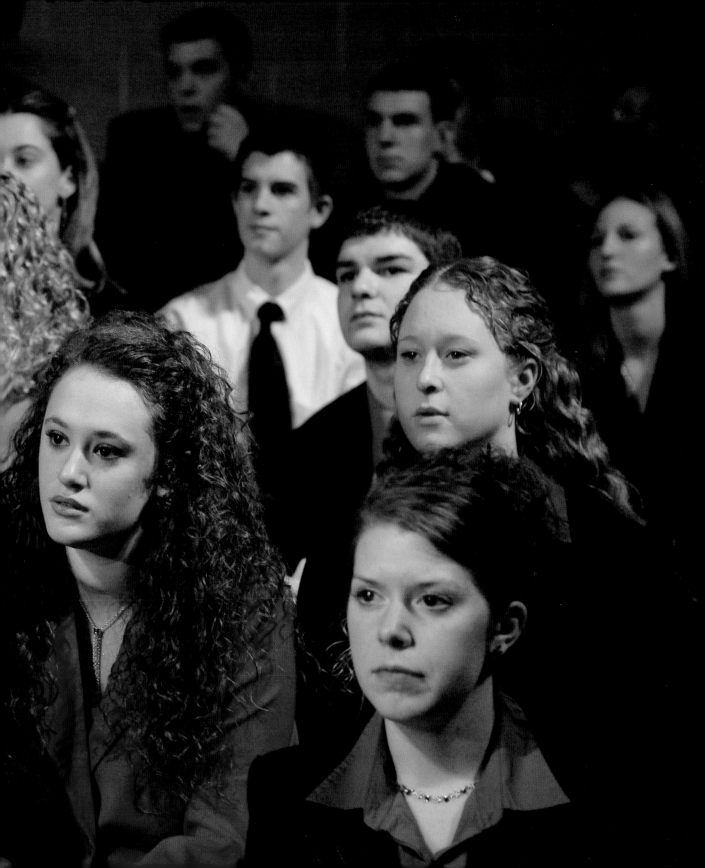

Vienna, Ohio 2004

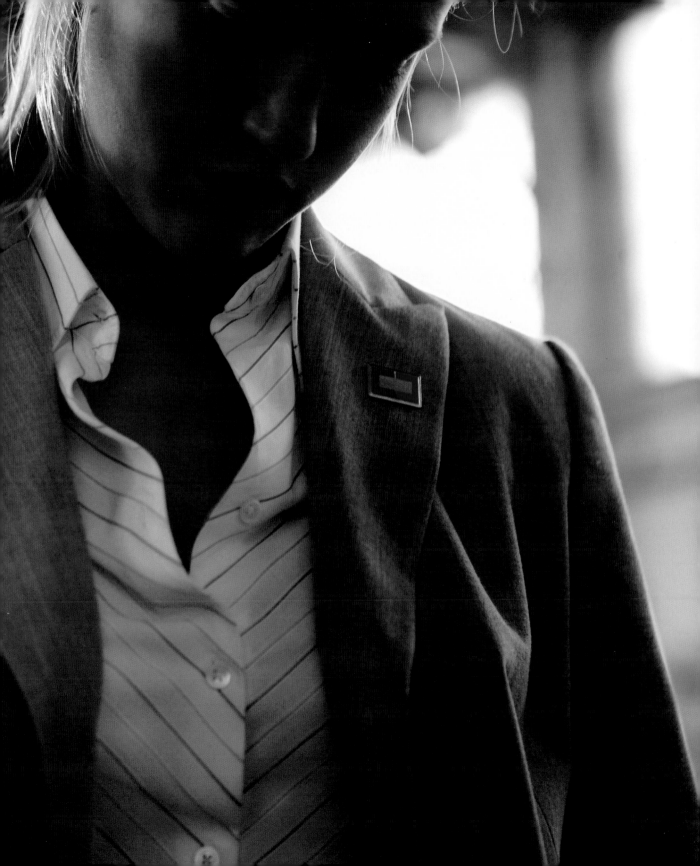

Washington, D.C. 2004

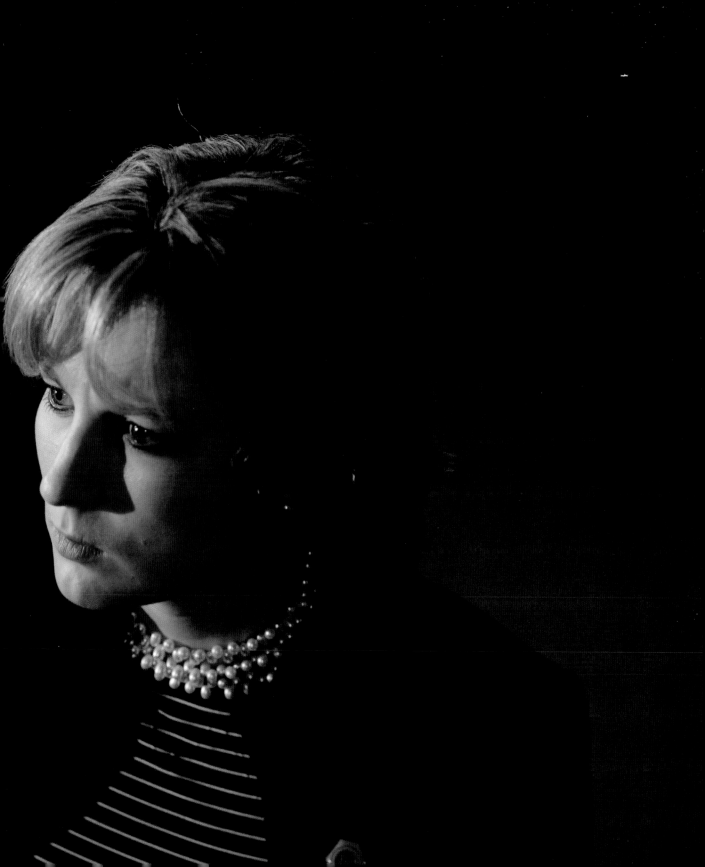

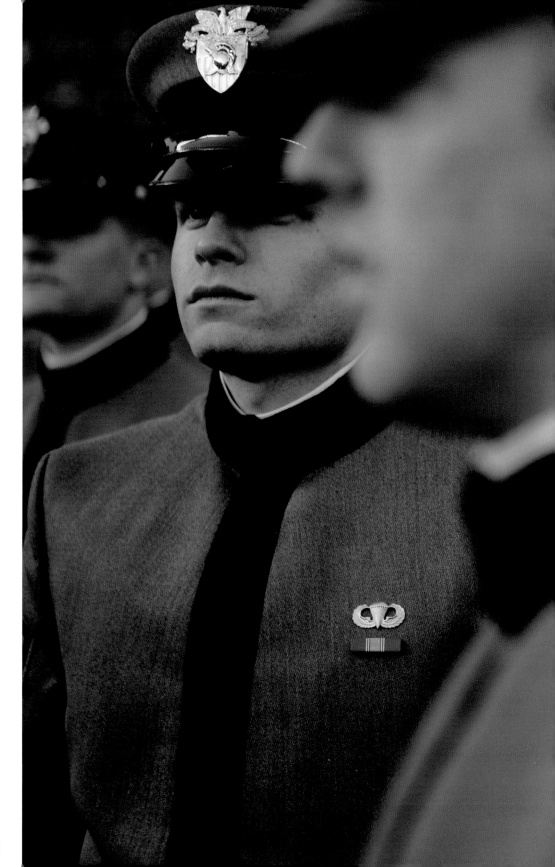

Philadelphia, Pennsylvania 2004

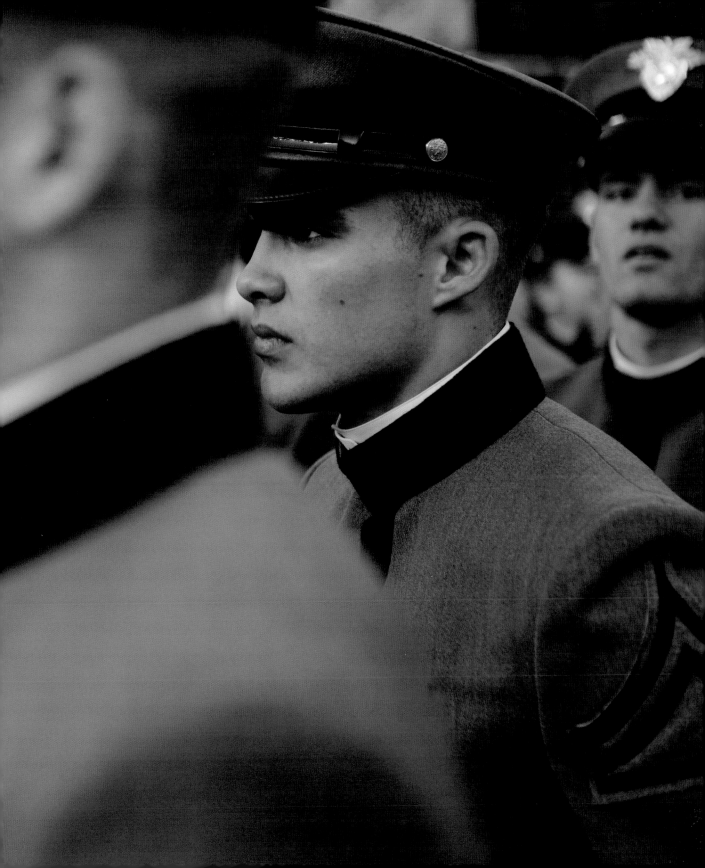

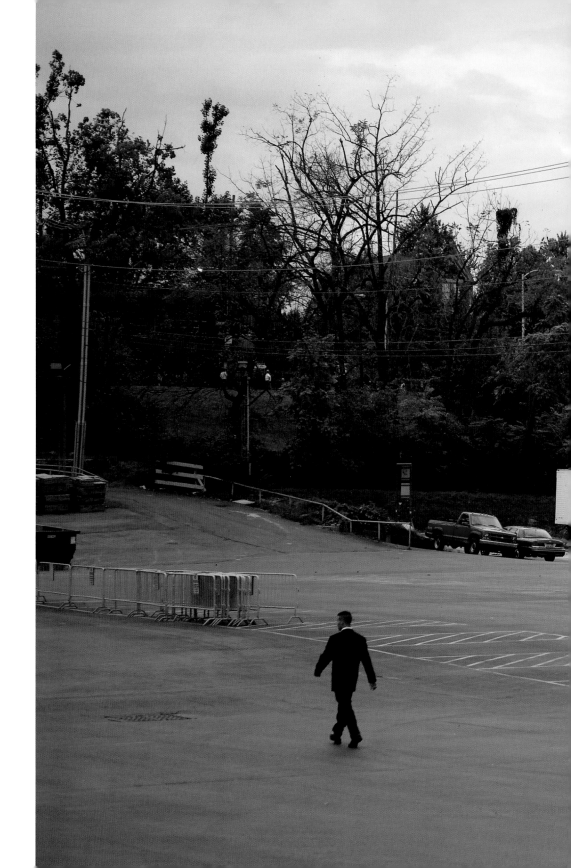

Lexington, Kentucky 2003

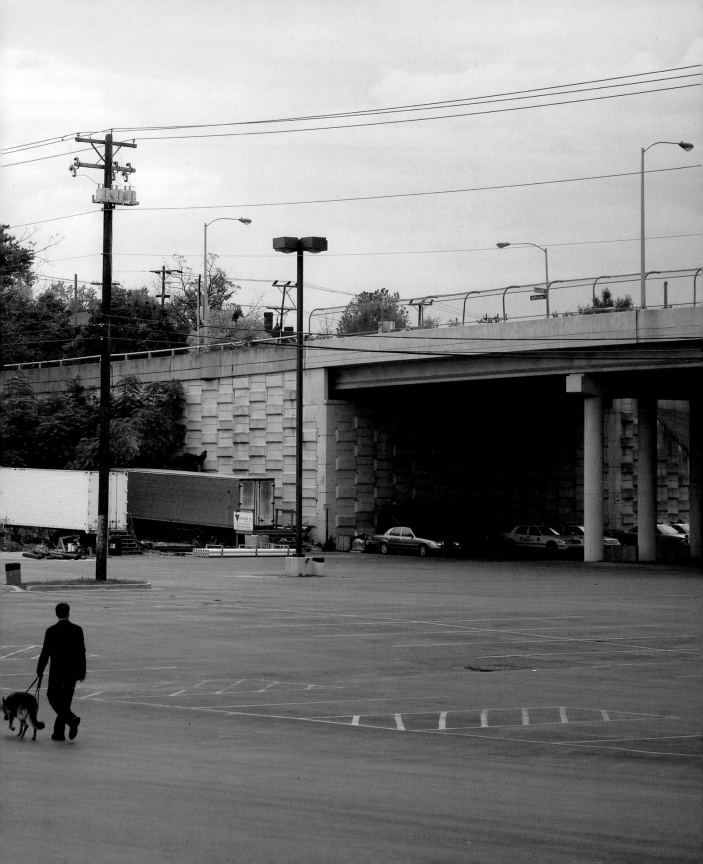

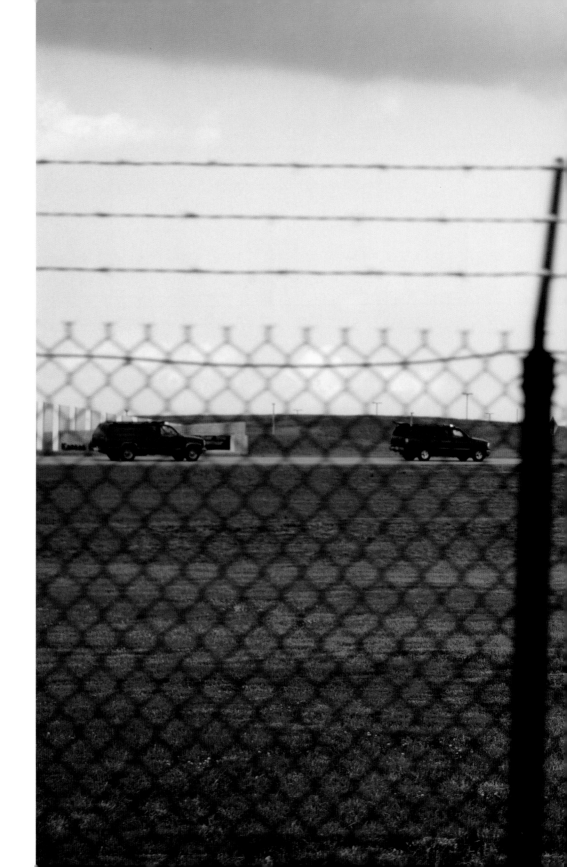

Liberty, Missouri 2004

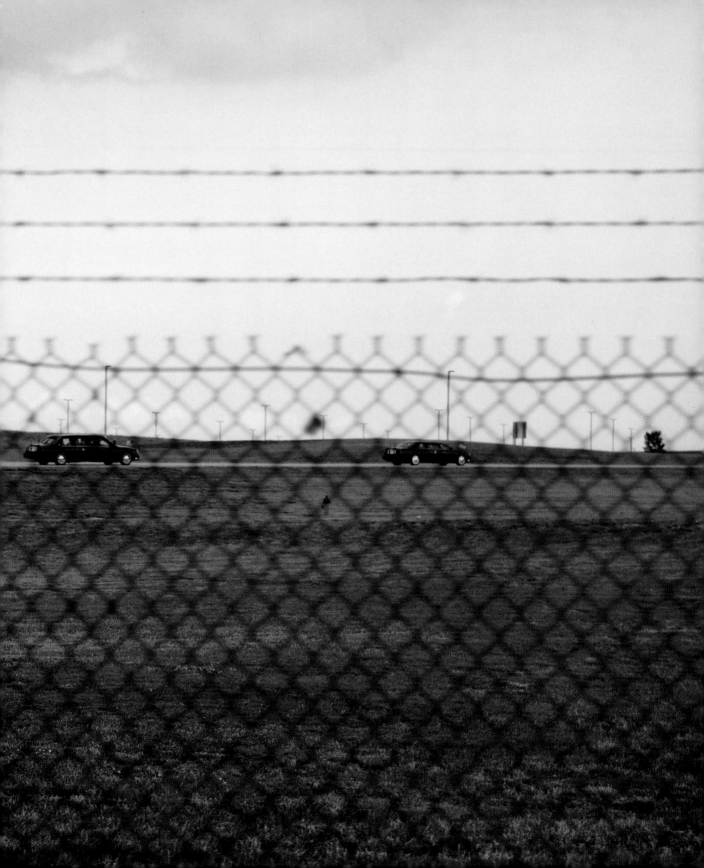

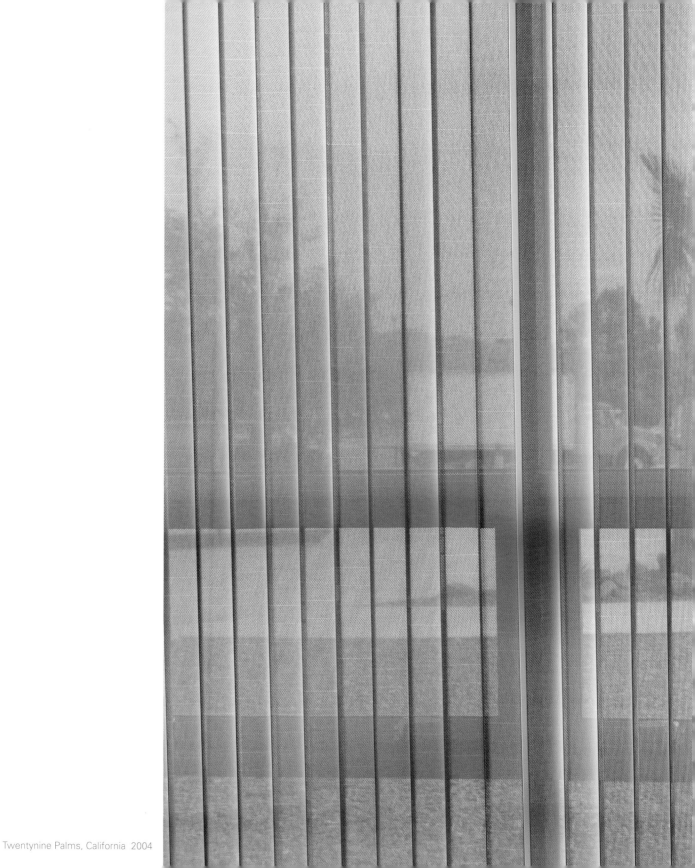

Twentynine Palms, California 2004

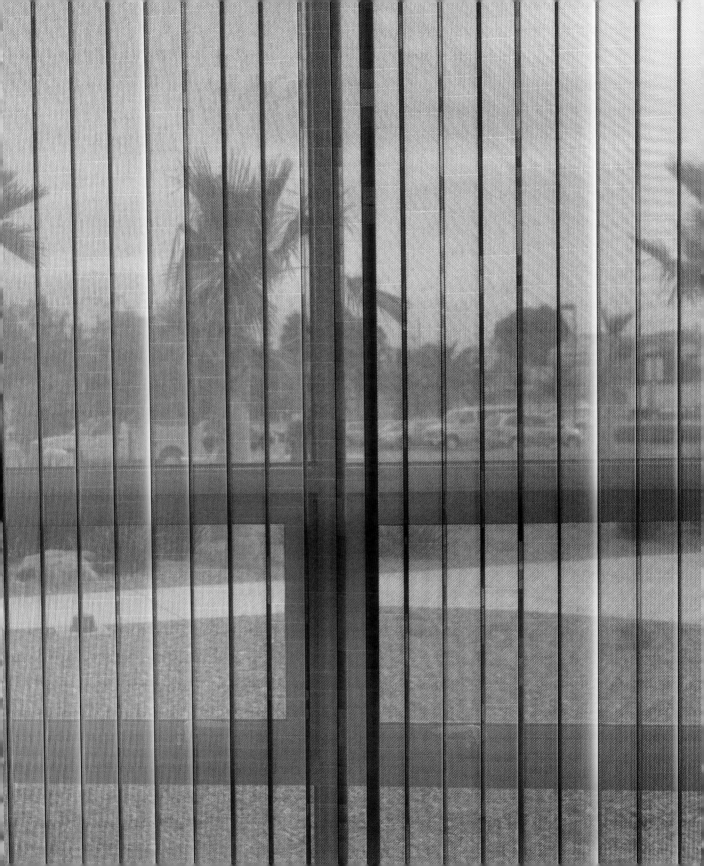

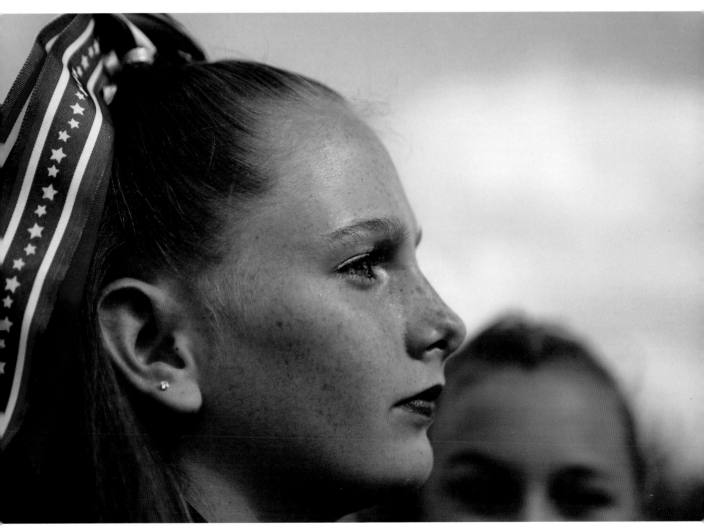

Tampa, Florida 2004

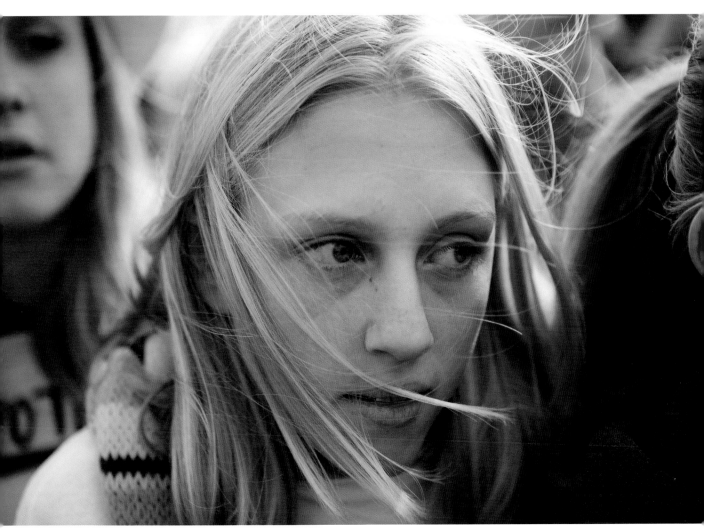

Lancaster County, Pennsylvania 2004

Steidl
Vale Studio
62 Wood Vale
London SE23 3ED
United Kingdom

Dear Book Collector

Thank you for buying one of our books.

We create the finest books on photography, contemporary art, fashion and literature. Steidl books are renowned worldwide for their incisive content and unparalleled production values. If you would like to receive our free catalogue, or for us to keep you up to date about our books, special offers and events, please fill out and return this card or visit our website at www.steidlville.com

Join our book club at www.steidlville.com/bookclub and receive benefits such as members only discounts, signed copies and priority booking for special events.

First Name _____ Last Name _____

Address _____

City _____ Post/Zip Code _____

Country _____ Email _____

Please send me:
- ☐ a free catalogue ☐ email newsletters
- ☐ details of special promotions and events by post

STEIDL

Welcome to Steidlville.com

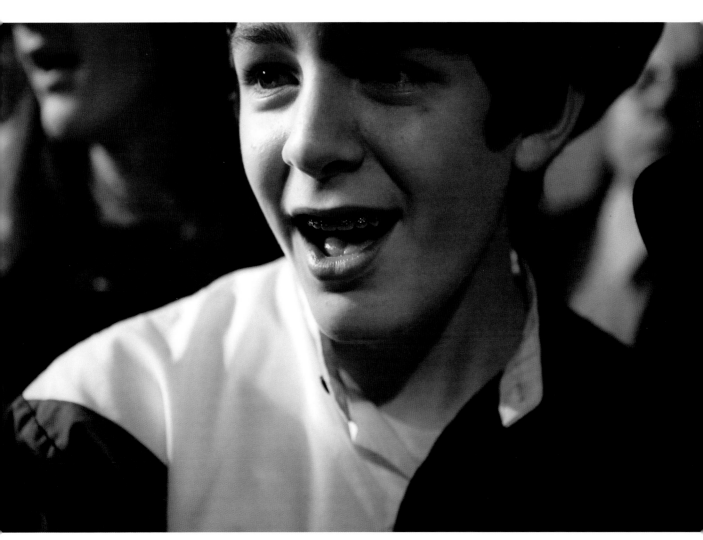

Saginaw, Michigan 2004

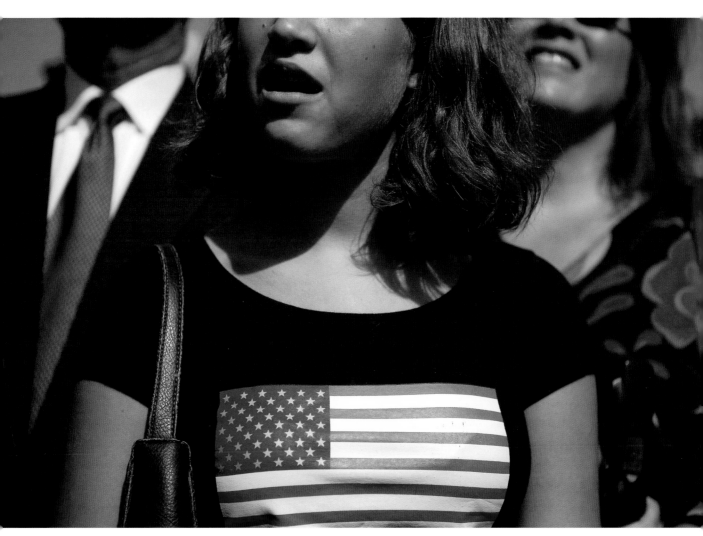

Dinuba, California 2003

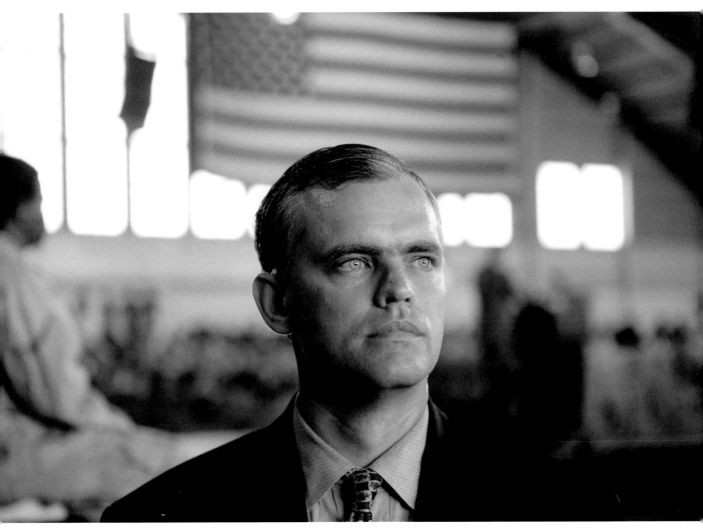

Tampa, Florida 2004

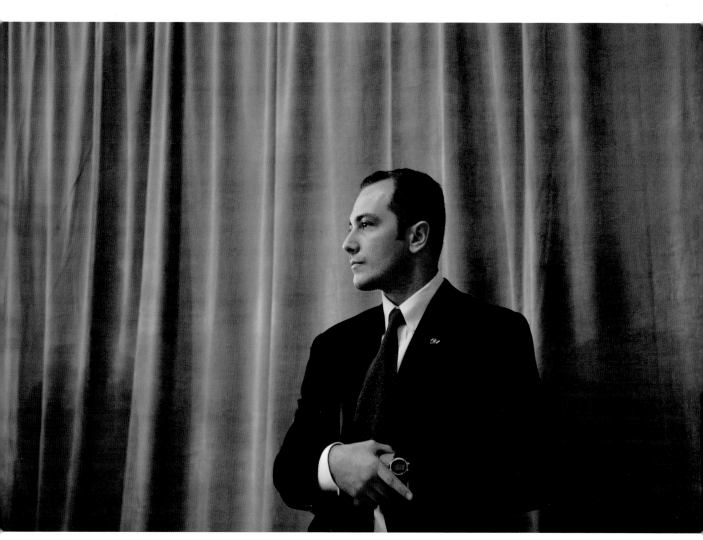

Tampa, Florida 2004

Greensboro, Georgia 2003

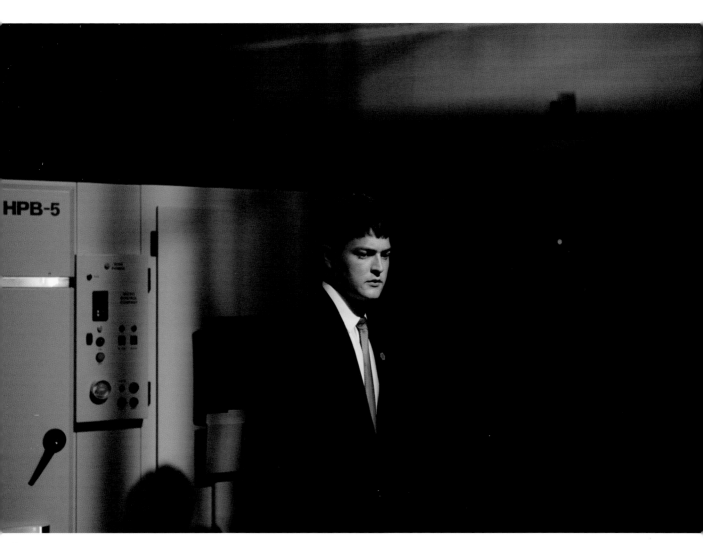

HPB-5

Fridley, Minnesota 2003

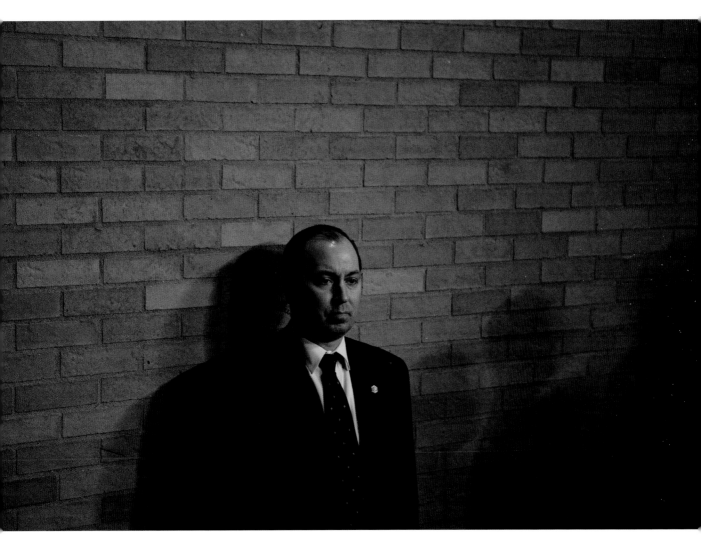

Washington, D.C. 2005

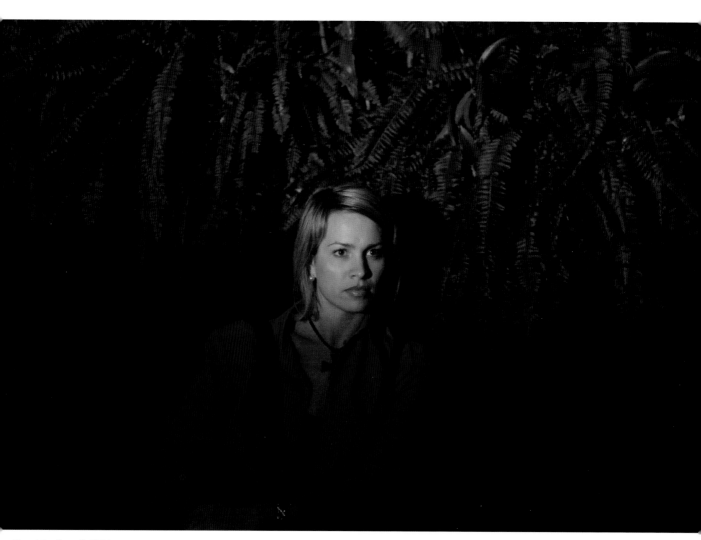

Honolulu, Hawaii 2003

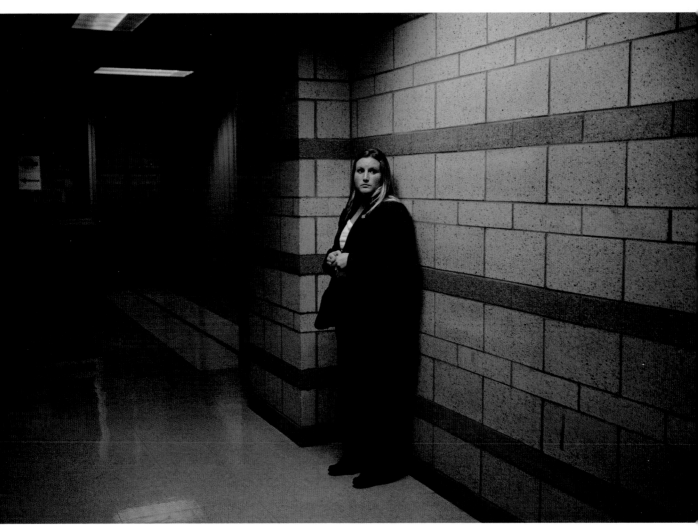

Dallas, Texas 2006

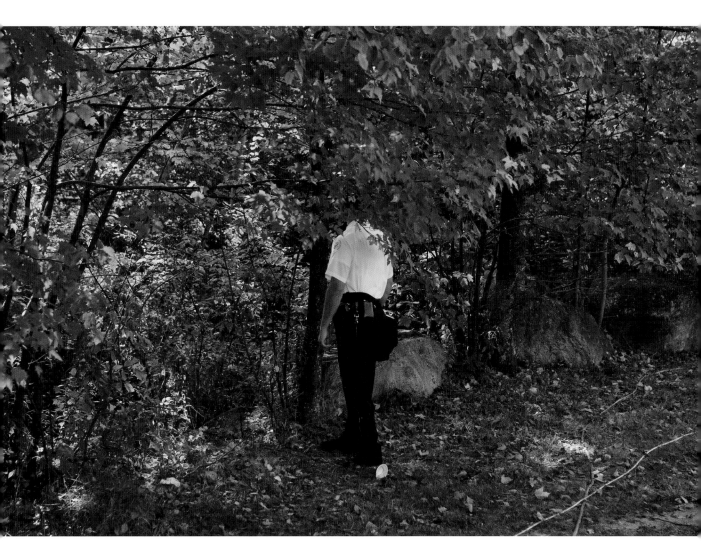

Manchester, New Hampshire 2004

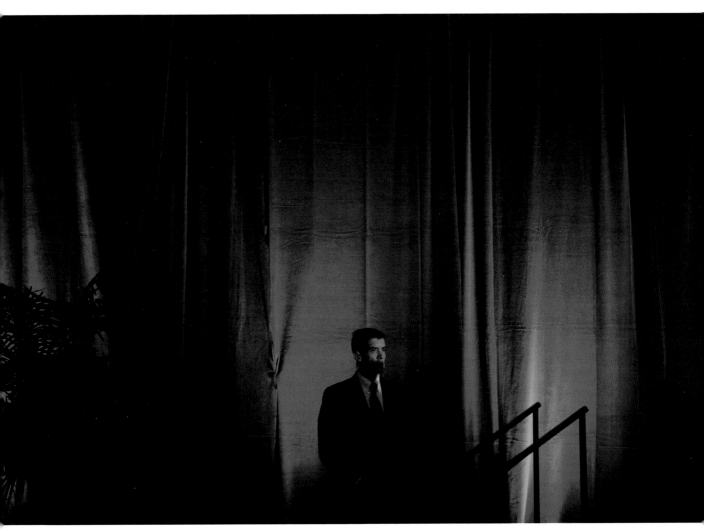

Washington, D.C. 2005

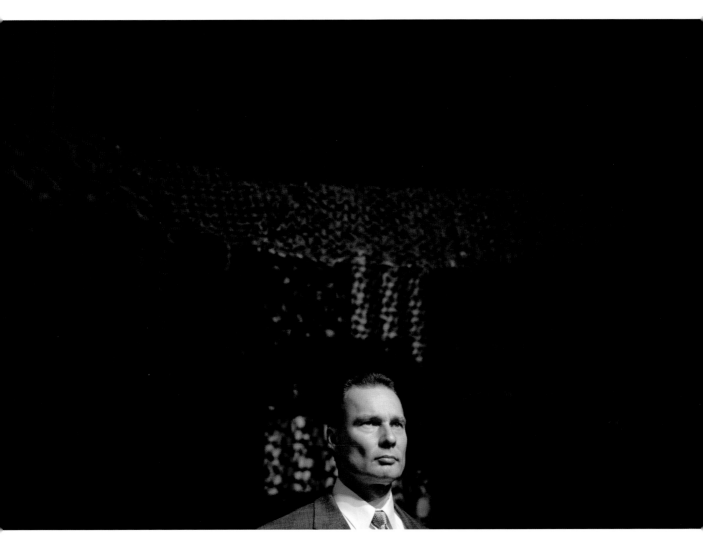

Portsmouth, New Hampshire 2003

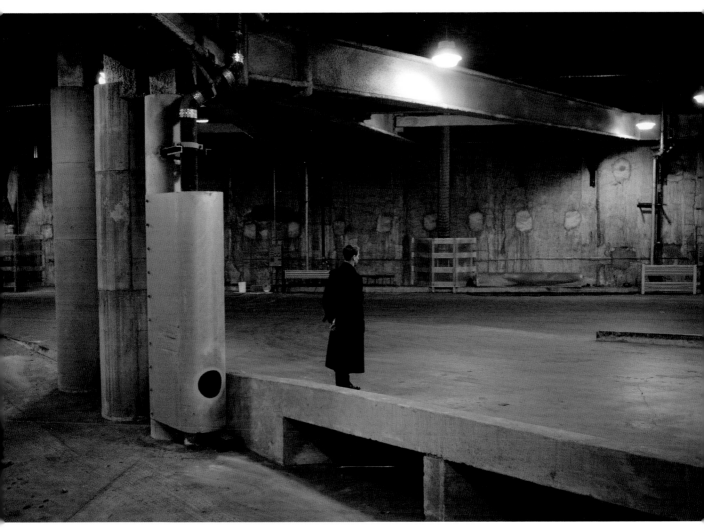

Washington, D.C. 2004

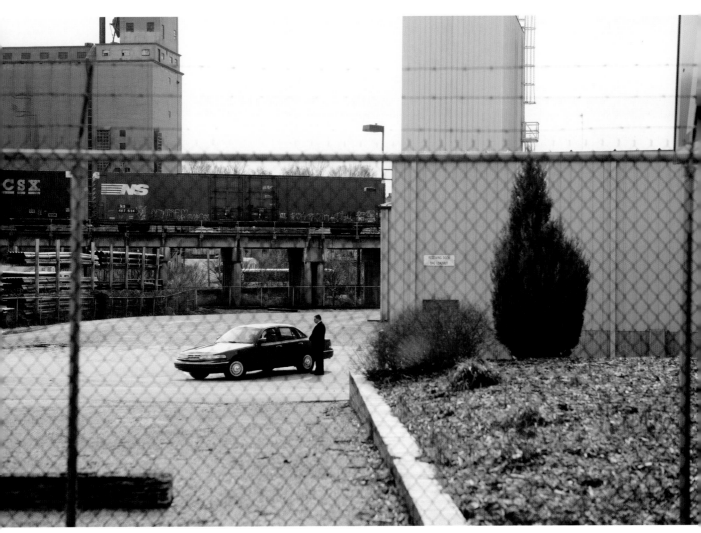

Louisville, Kentucky 2004

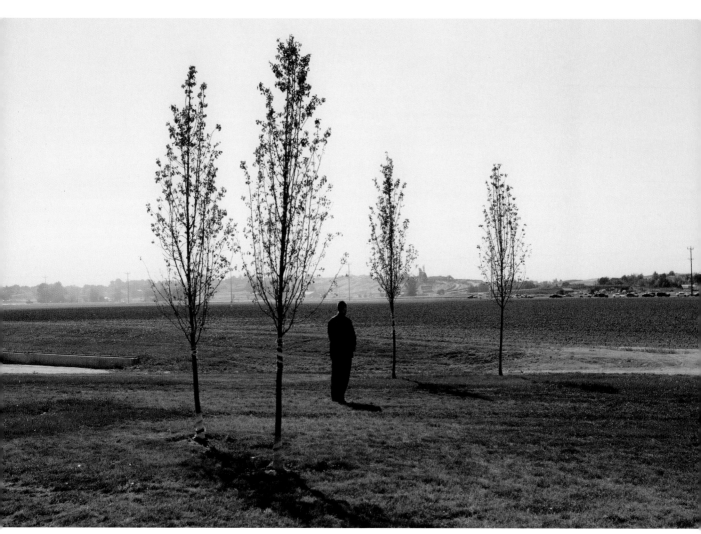

Nampa, Idaho 2005

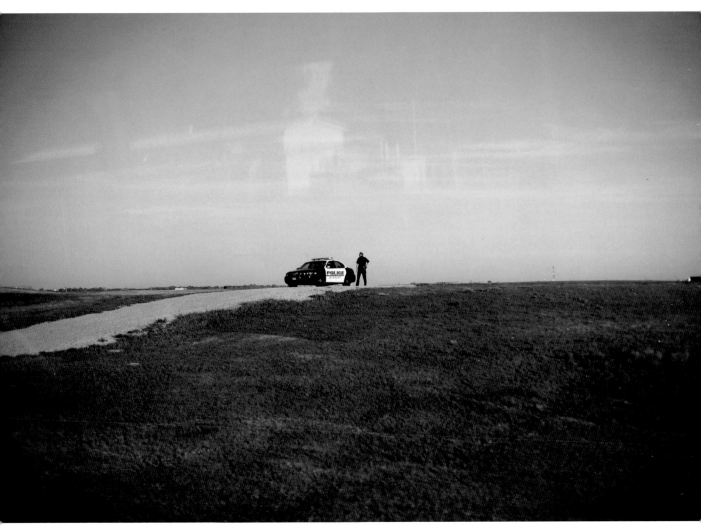

Hudson, Wisconsin 2004

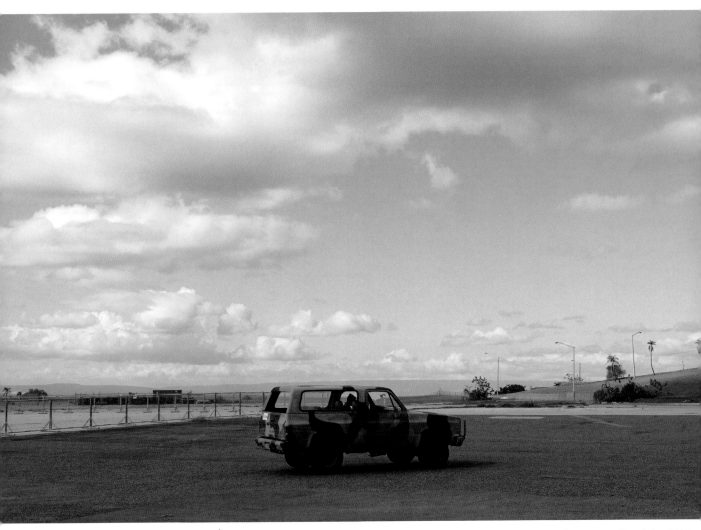

Guantanamo Bay, Cuba 2003

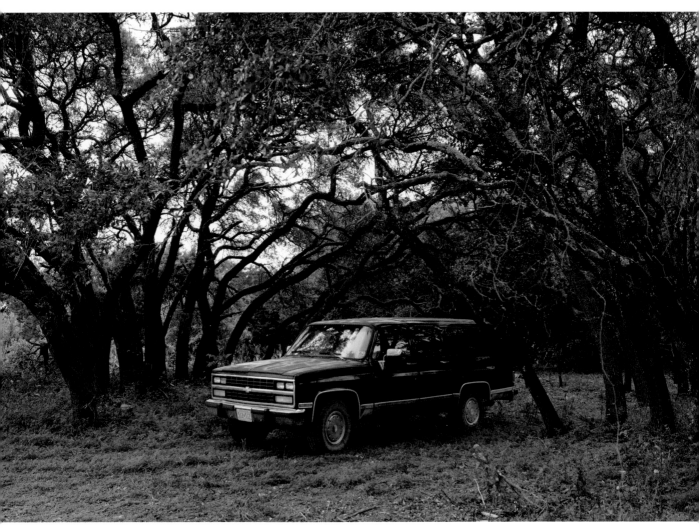

Crawford, Texas 2005

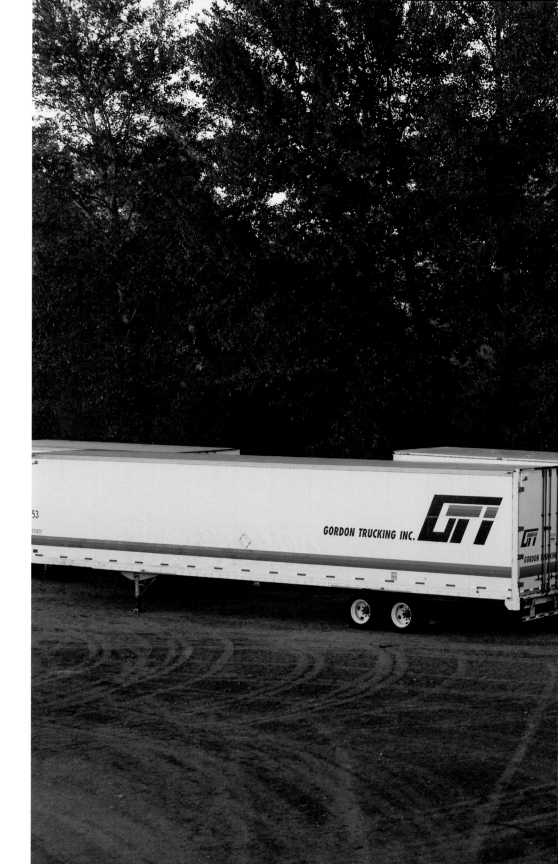

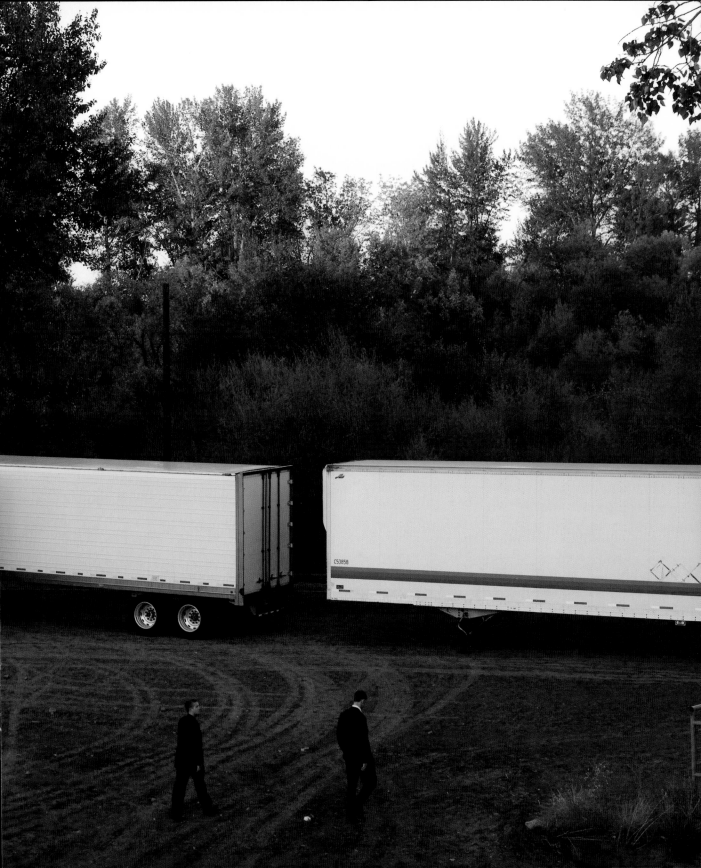

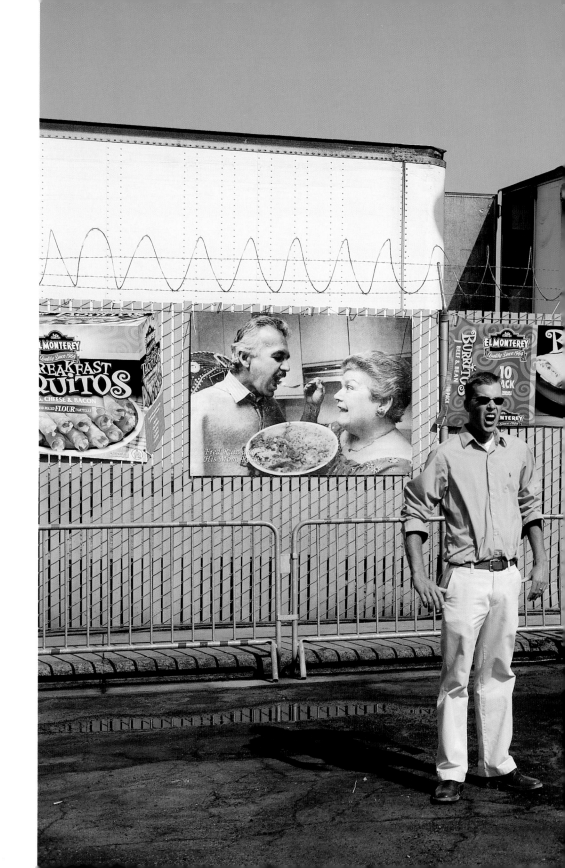

Dinuba, California 2003

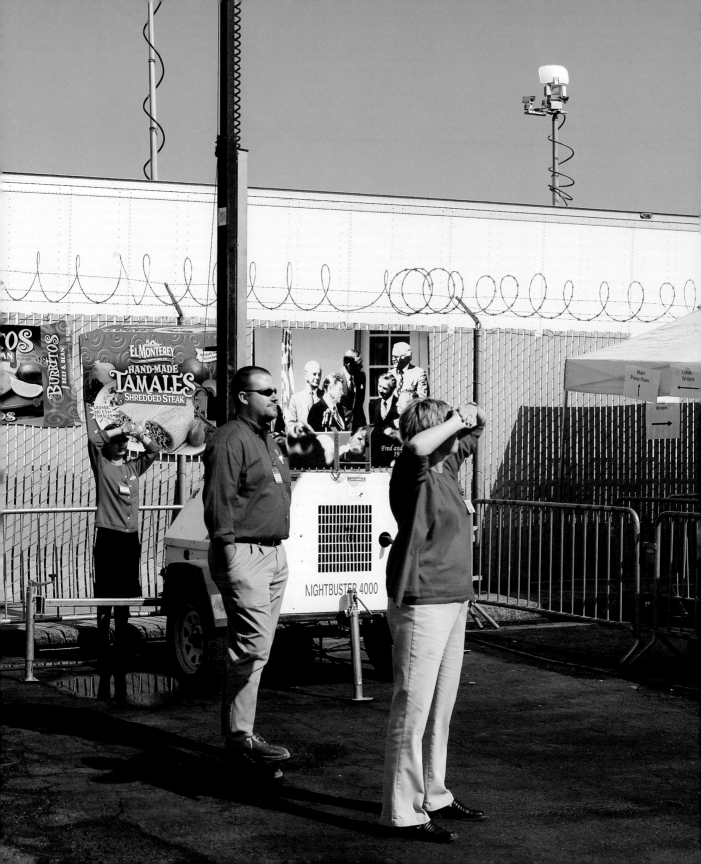

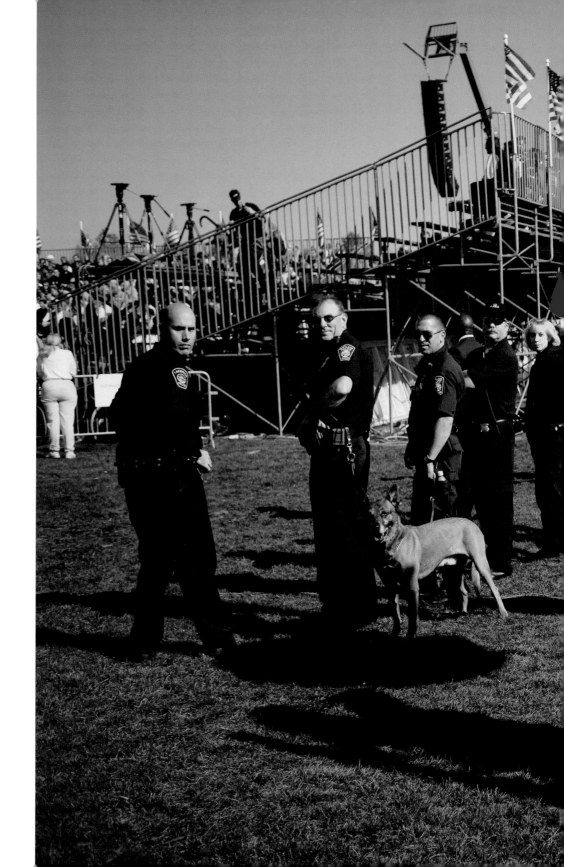

Westlake, Ohio, 2004

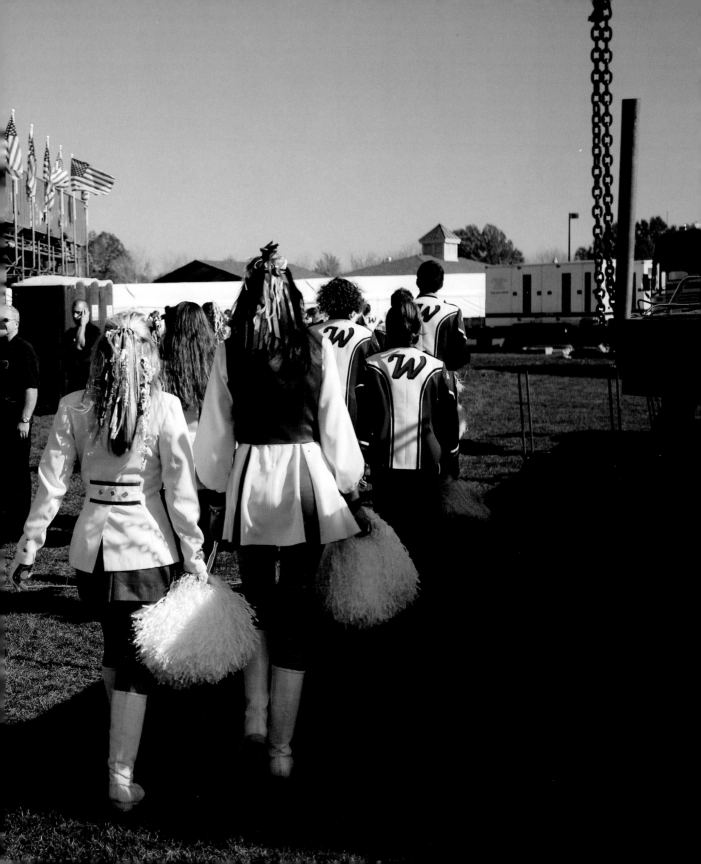

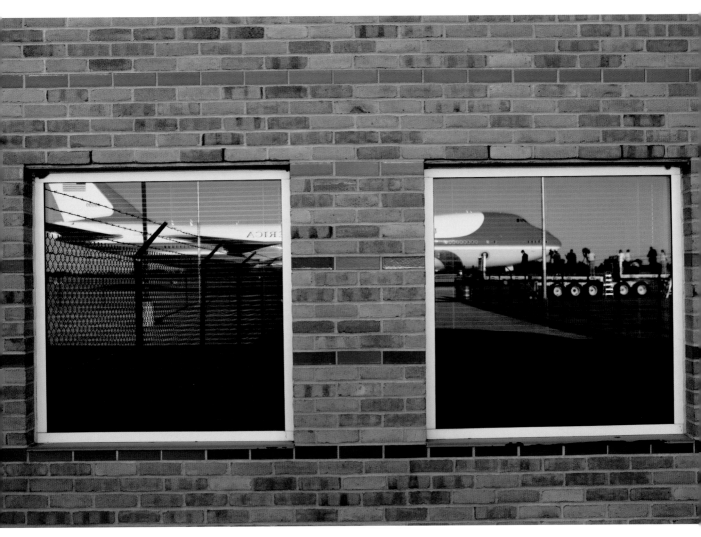

Columbus, Ohio 2004

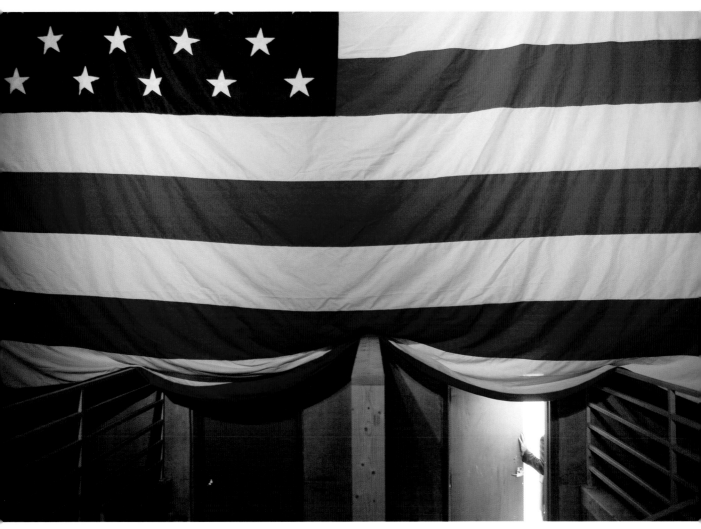

Fridley, Minnesota 2003

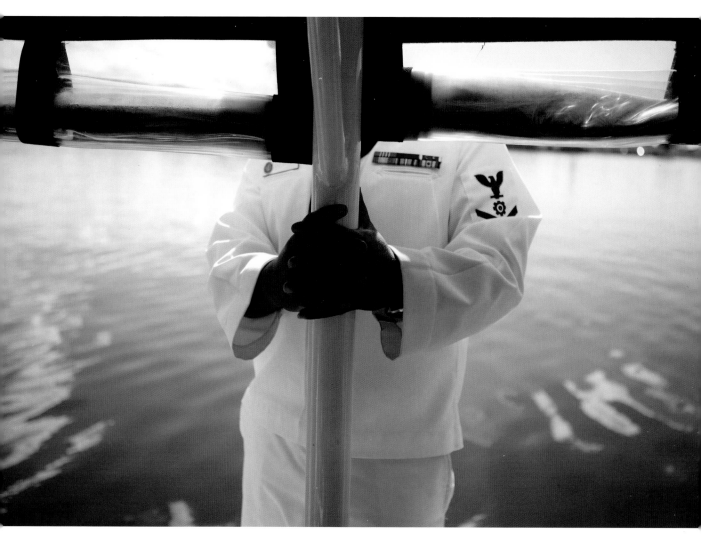

Pearl Harbor, Hawaii 2003

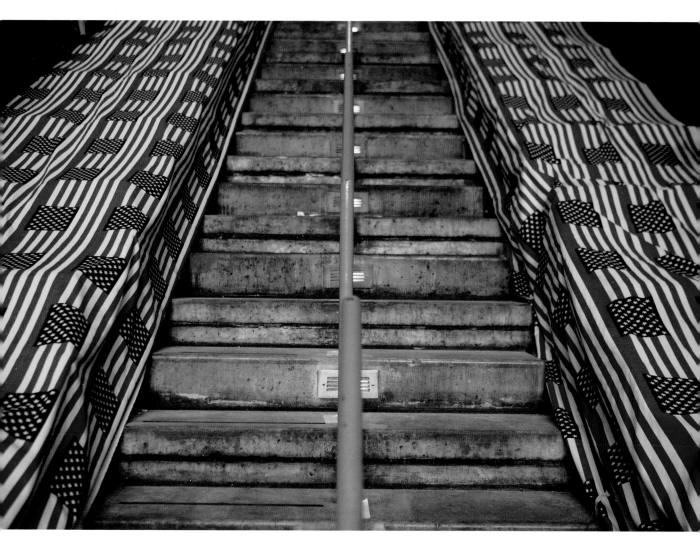

Pensacola, Florida 2004

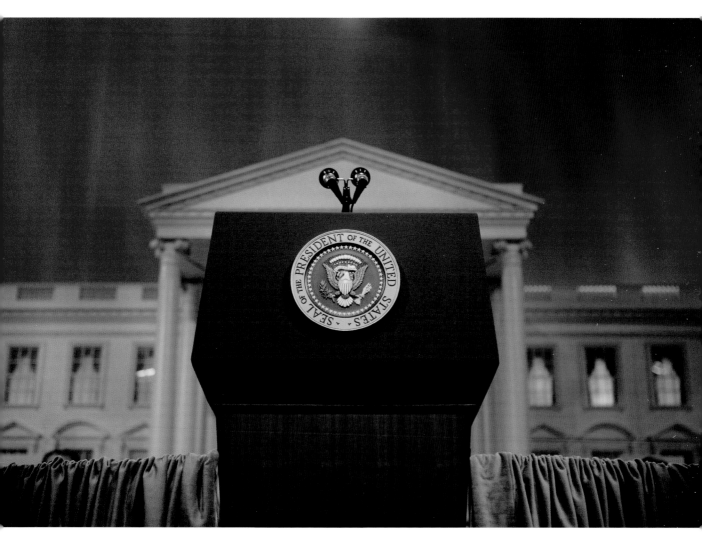

Washington, D.C. 2005

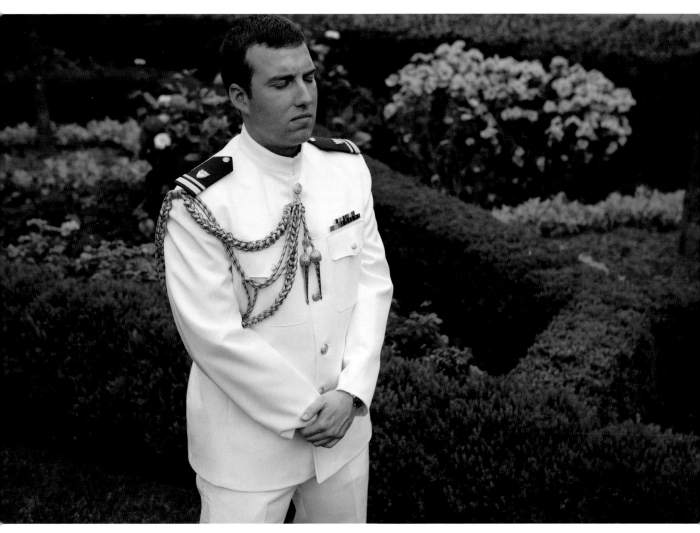

Washington, D.C. 2005

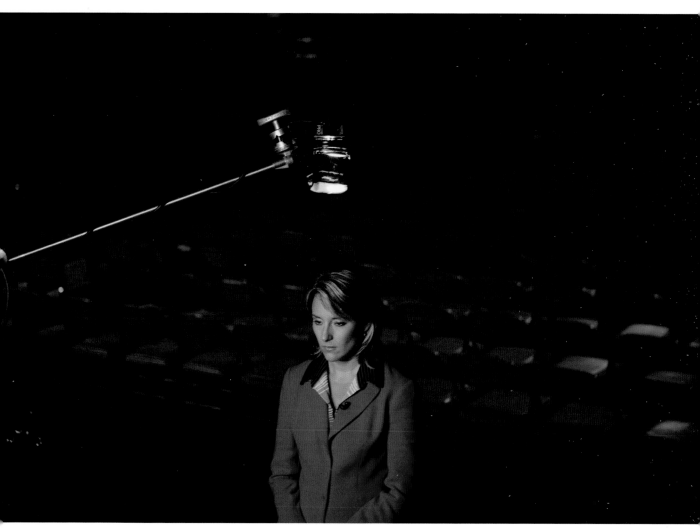

Fayetteville, North Carolina 2005

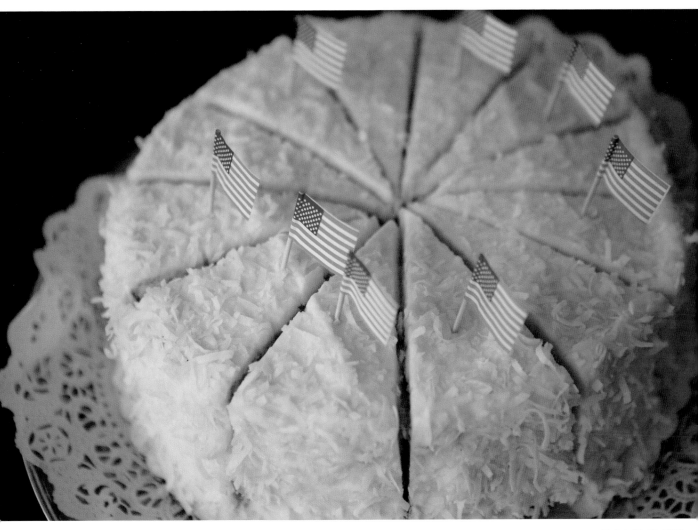

Dallas, Texas 2004

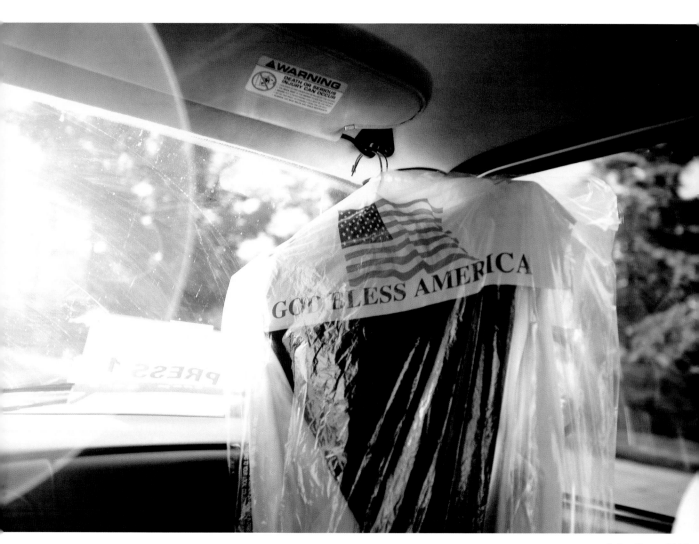

Dallas, Texas 2004

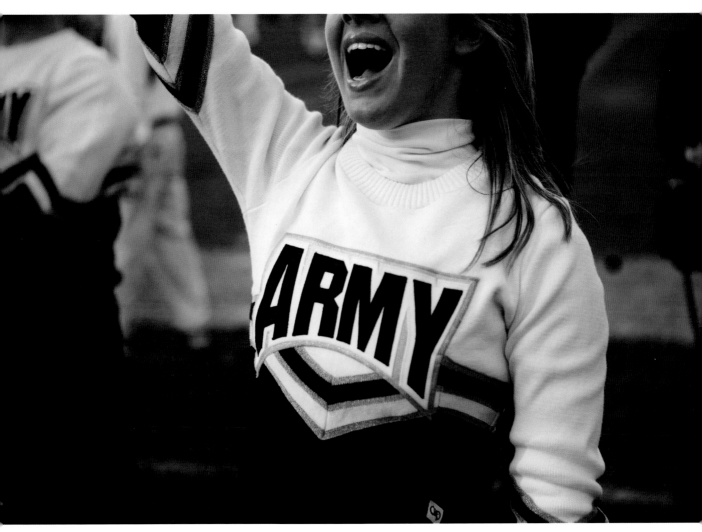

Philadelphia, Pennsylvania 2004

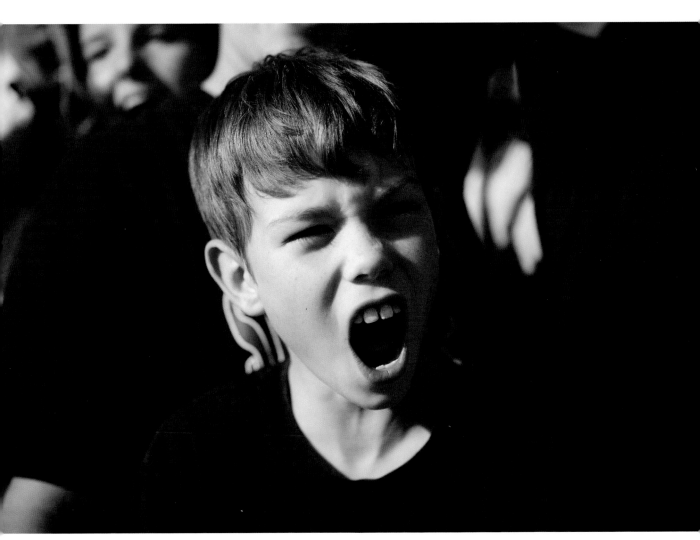

Westlake, Ohio 2004

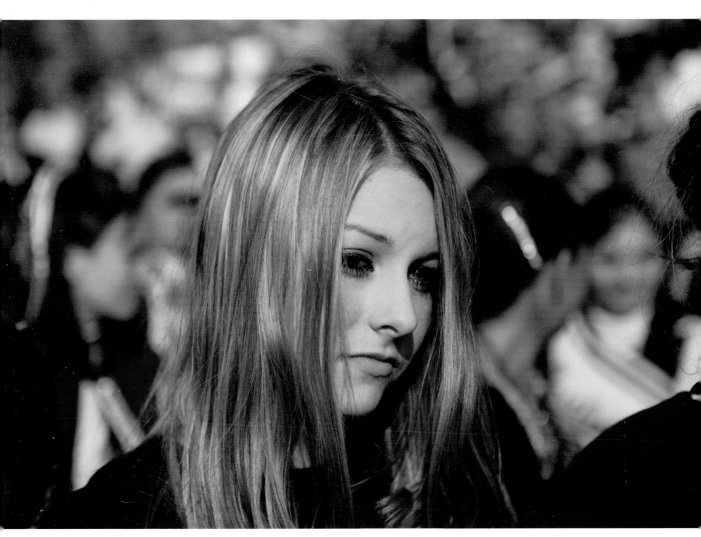

Westlake, Ohio 2004

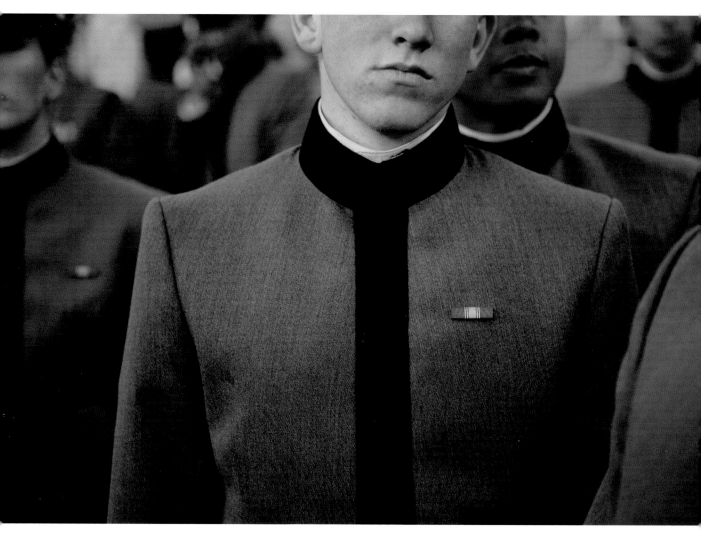

Philadelphia, Pennsylvania 2004

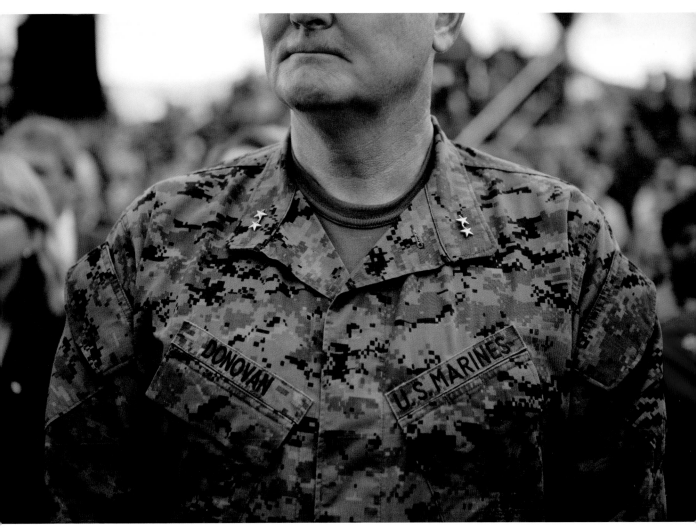

Camp Pendleton, California 2004

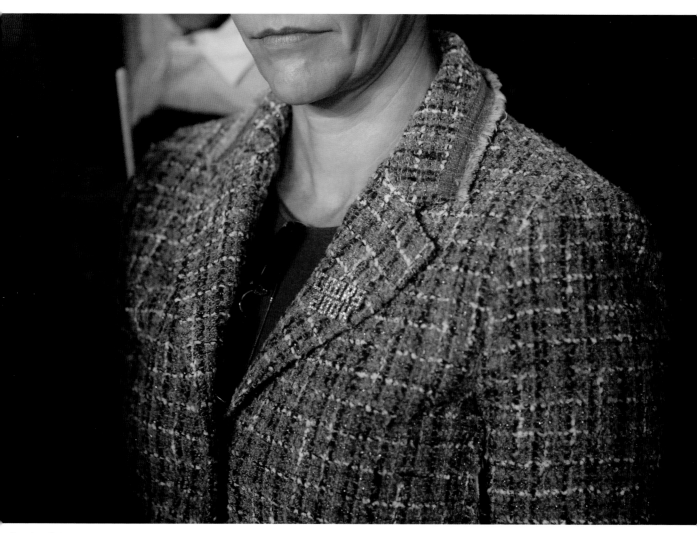

Greeley, Colorado 2004

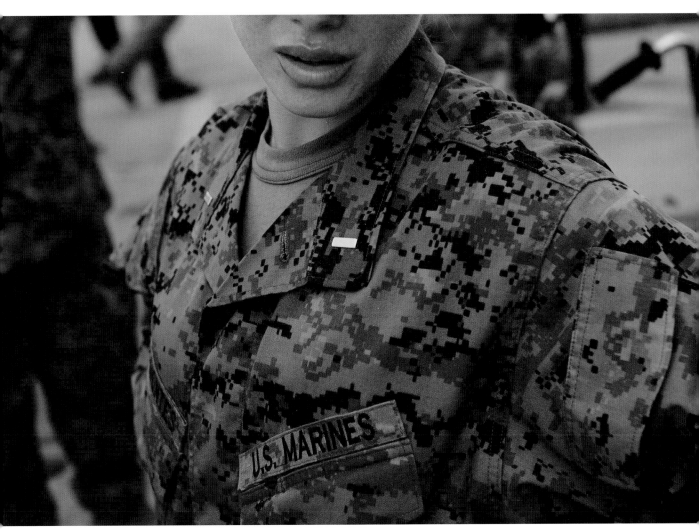

Chalmette, Louisiana 2005

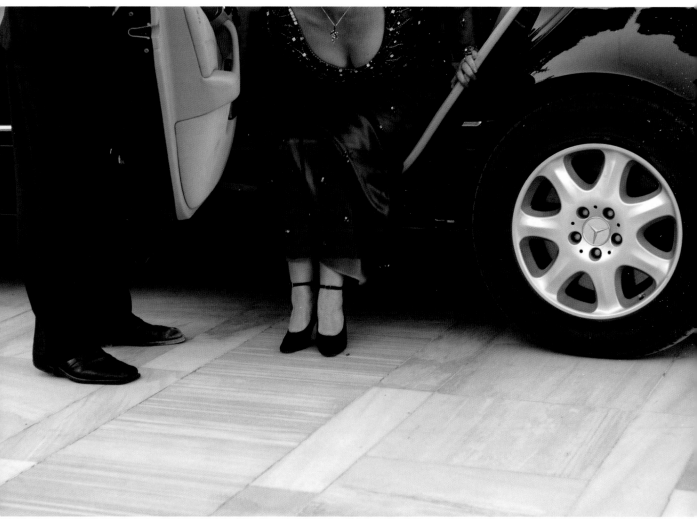

Istanbul, Turkey 2004

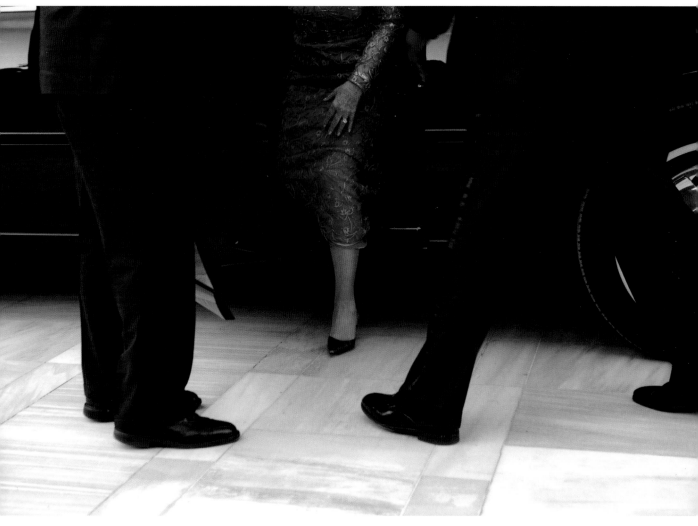

Istanbul, Turkey 2004

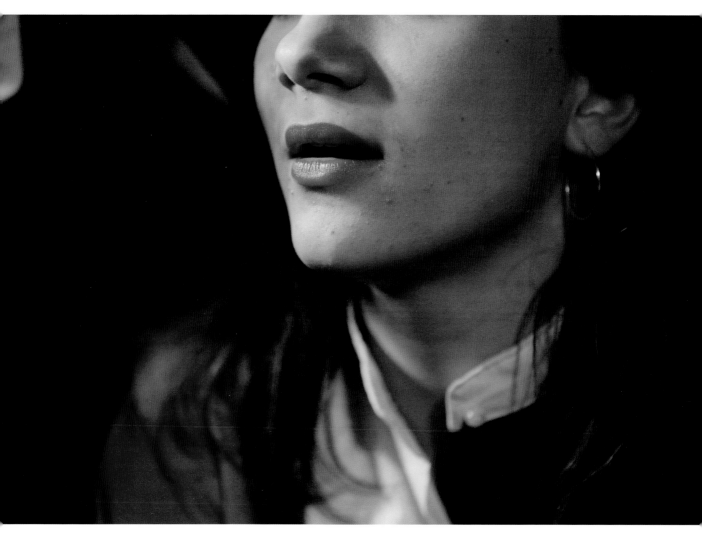

Saginaw, Michigan 2004

Washington, D.C. 2005

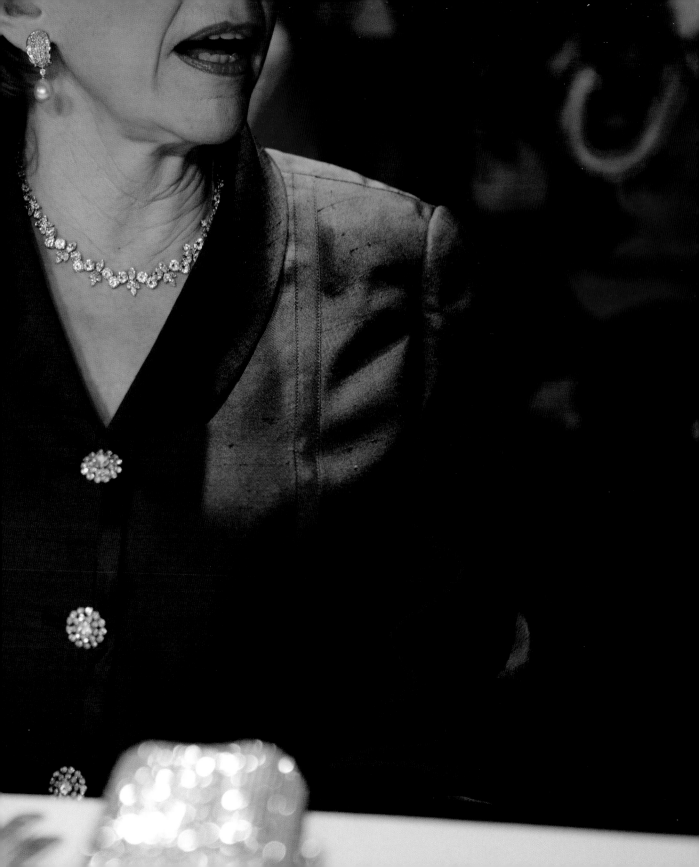

Washington, D.C. 2005

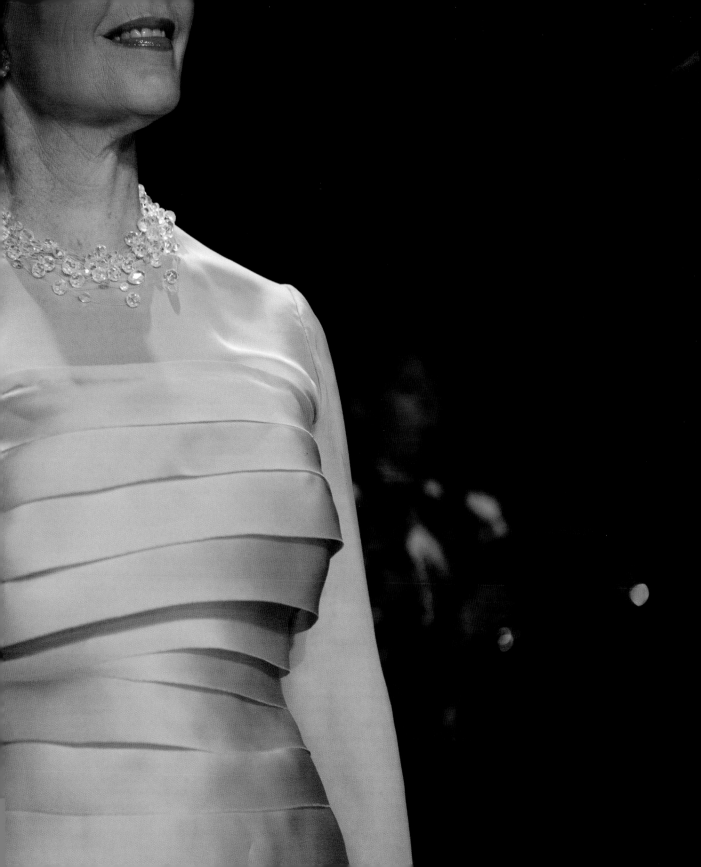

Washington, D.C. 2005

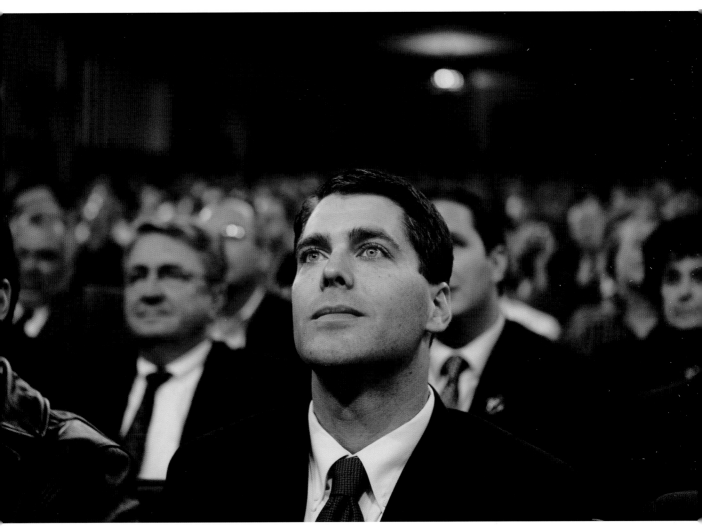

Farmington Hills, Michigan 2004

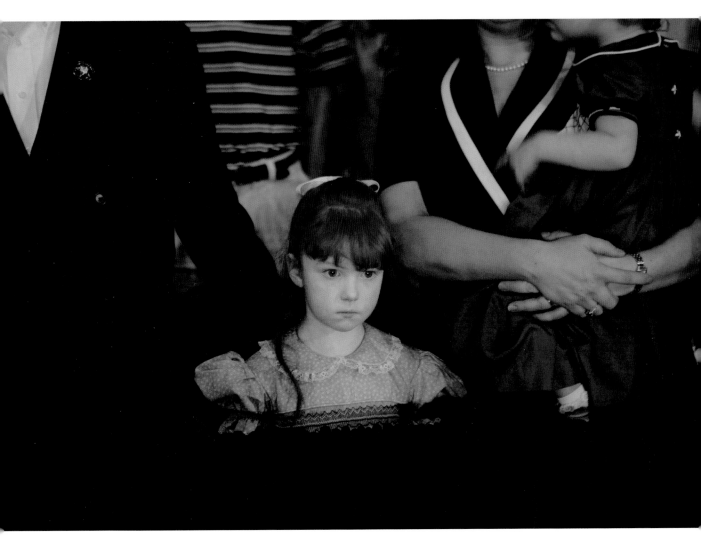

Annandale, Virginia 2004

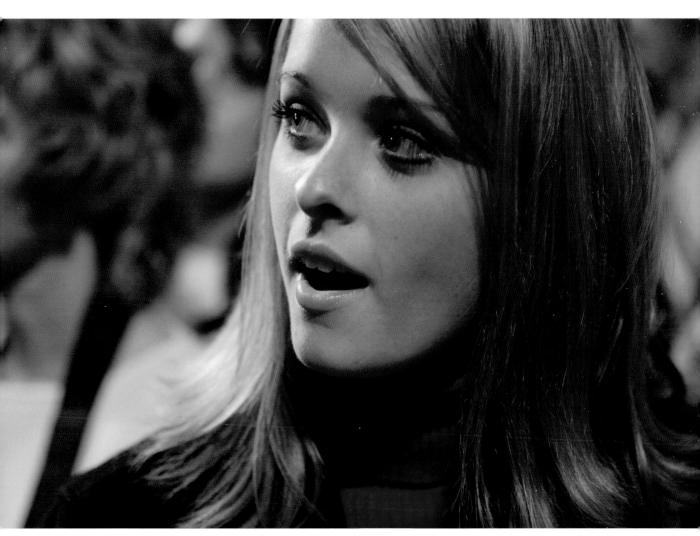

Saginaw, Michigan 2004

New York, New York 2004

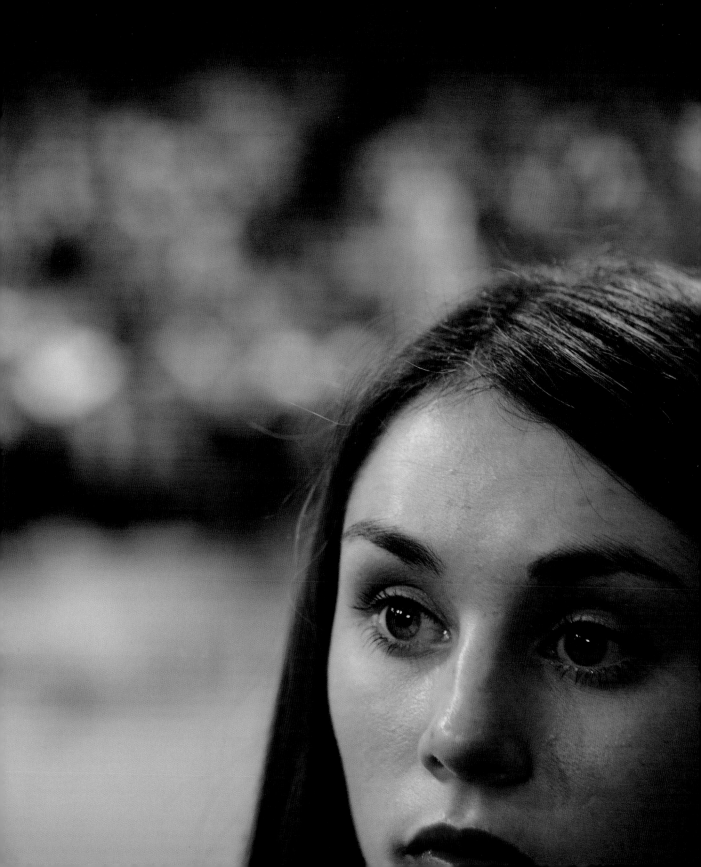

Washington, D.C. 2003

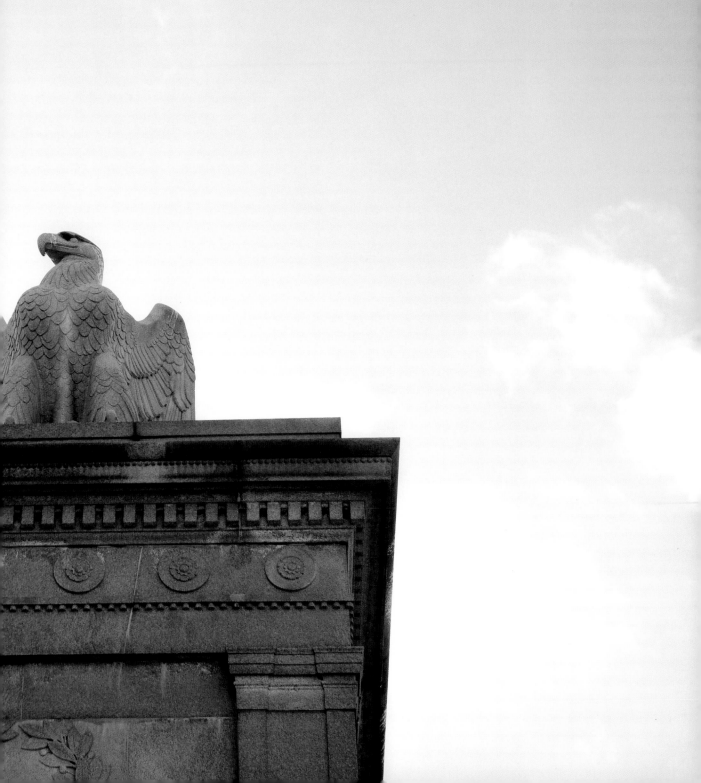

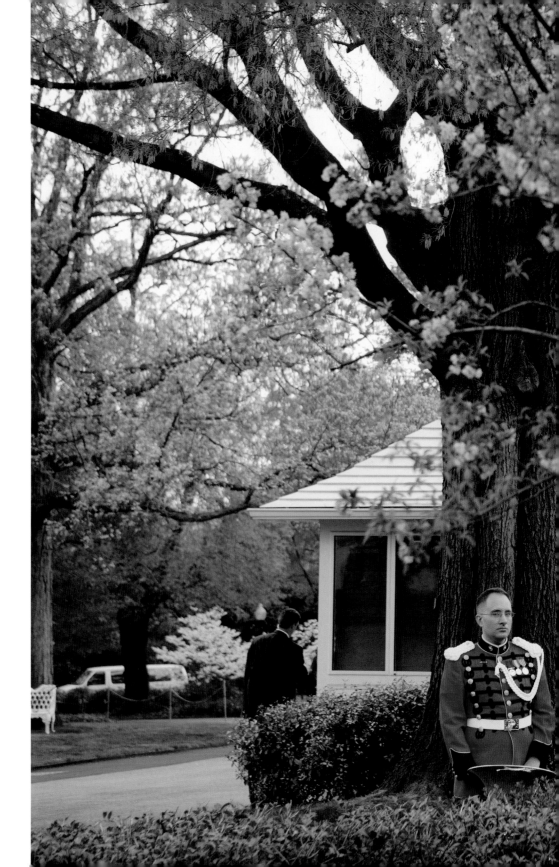

Washington, D.C. 2005

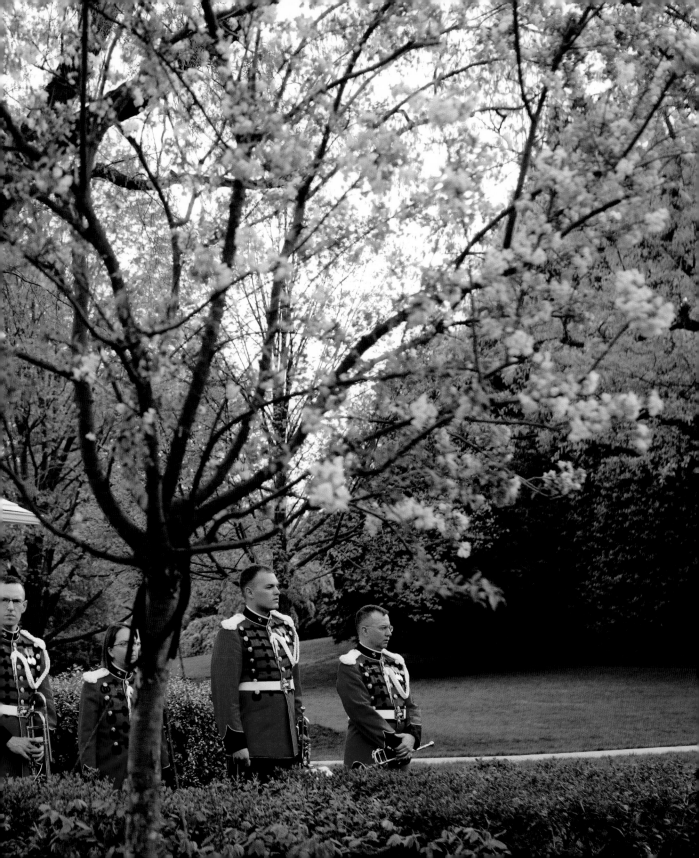

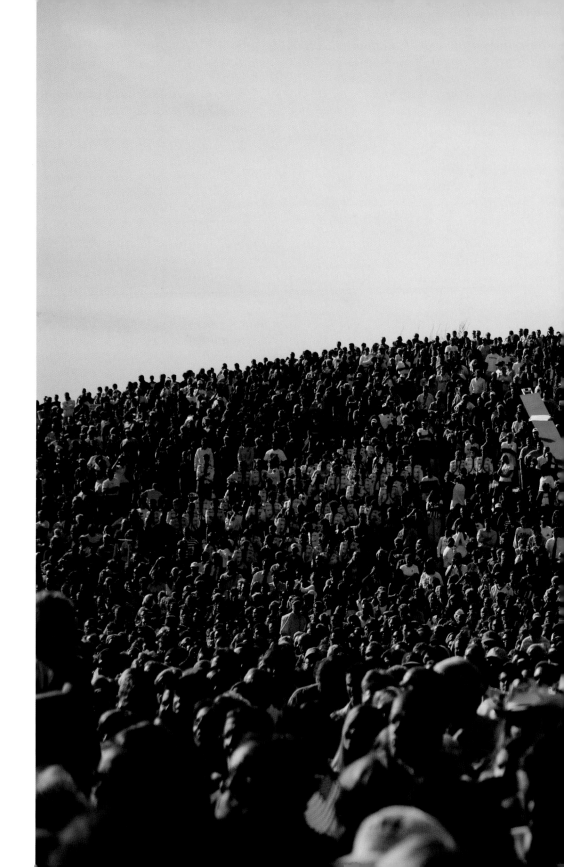

Westlake, Ohio 2004

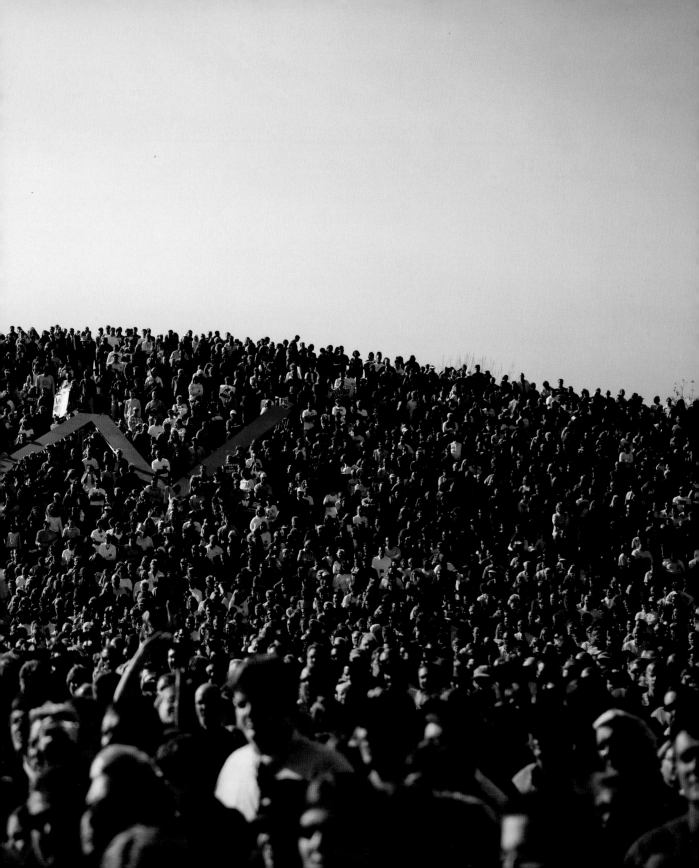

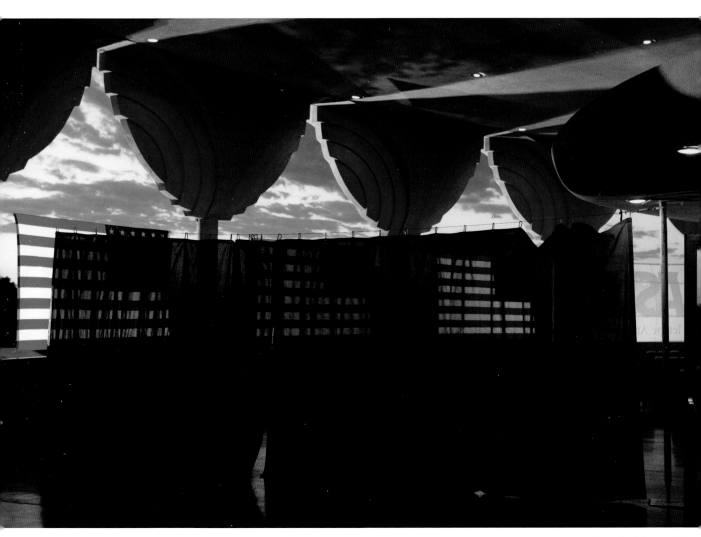

Phoenix, Arizona 2004

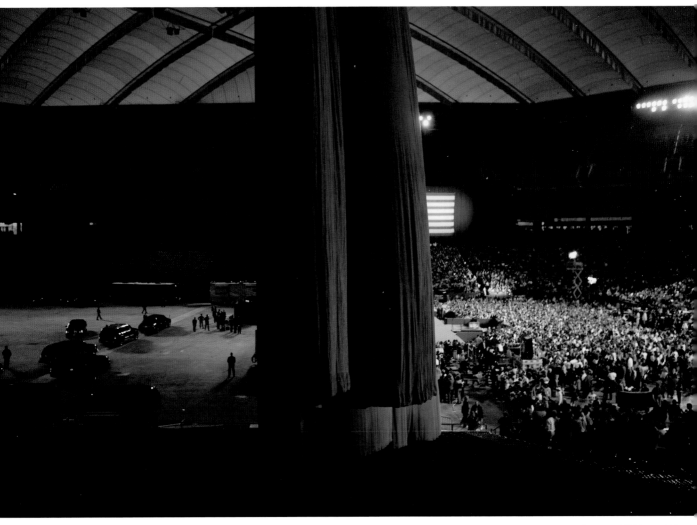

Pontiac, Michigan 2004

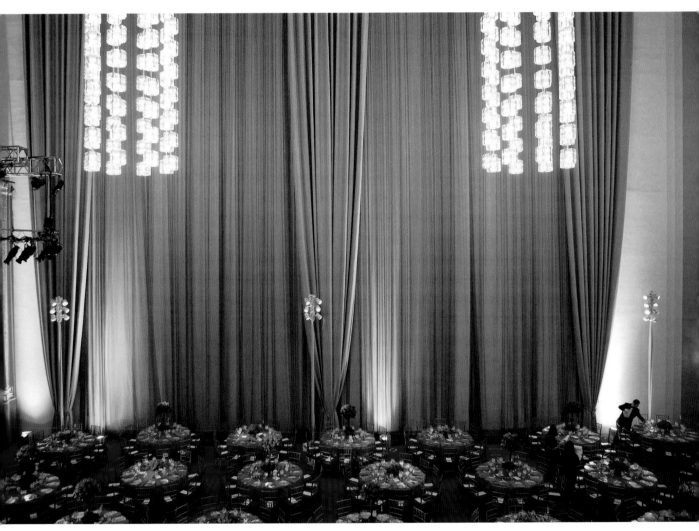

Washington, D.C. 2003

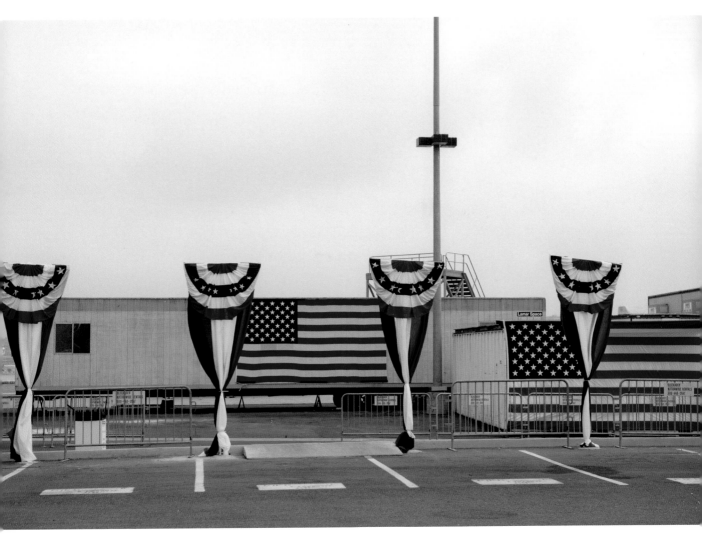

Coronado, California 2005

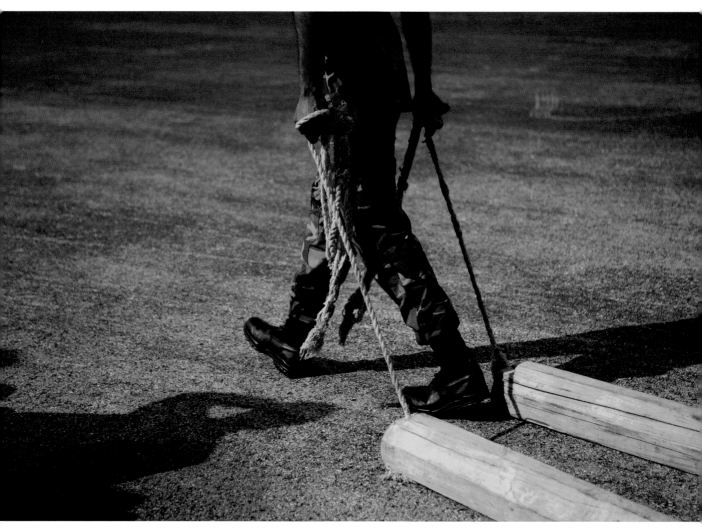

Tampa, Florida 2004

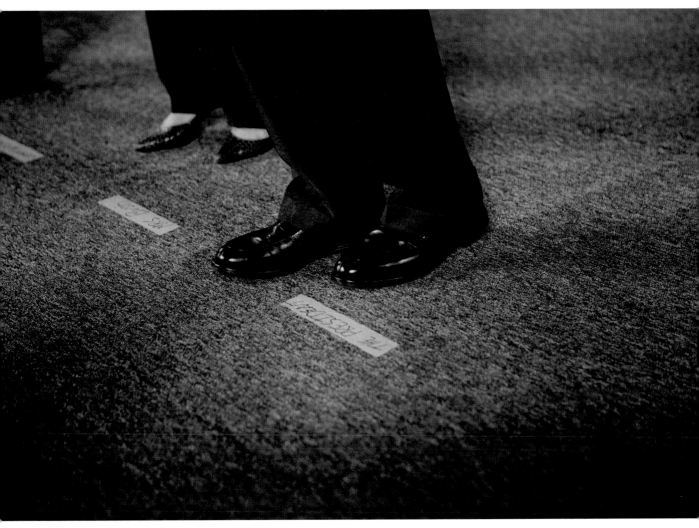

Pontiac, Michigan 2004

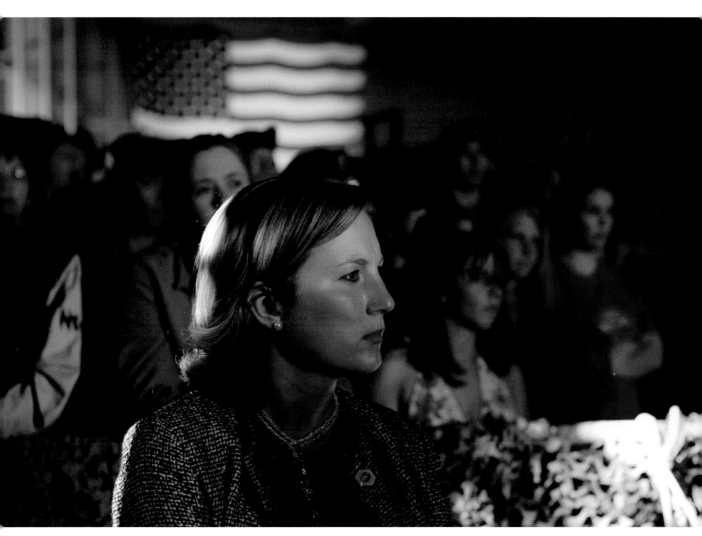

Ft. Lewis, Washington 2004

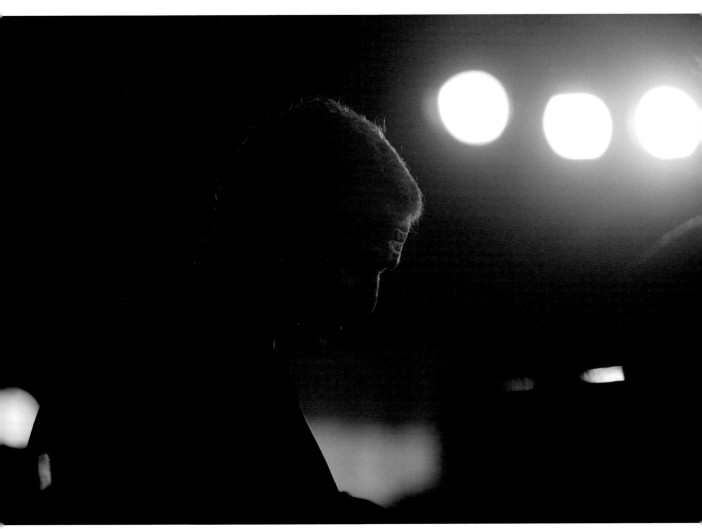

El Dorado, Arkansas 2004

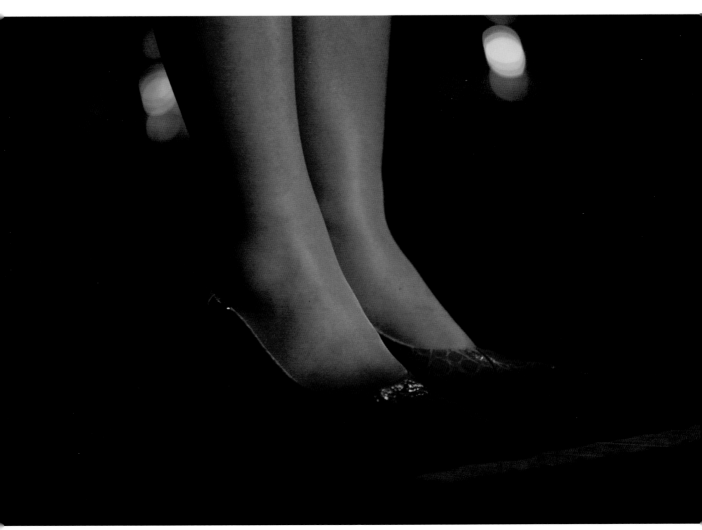

Honolulu, Hawaii 2003

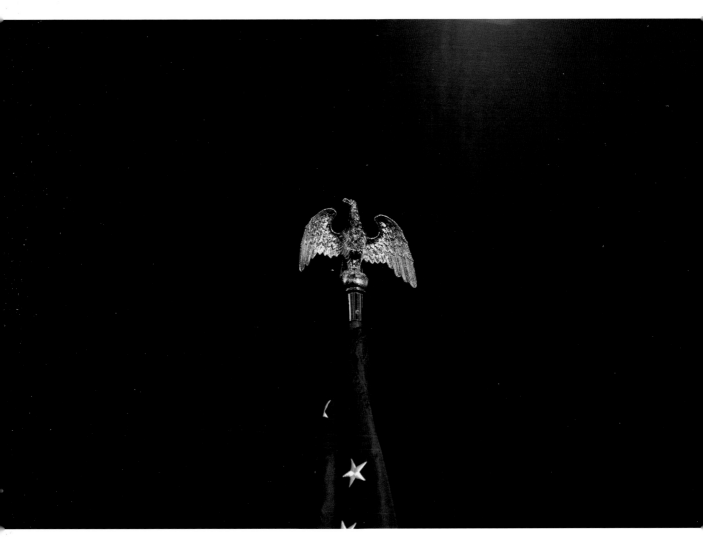

Louisville, Kentucky 2004

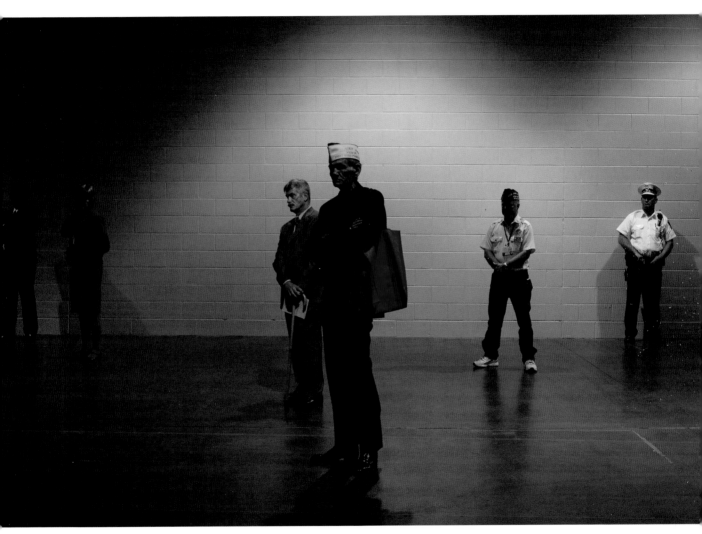

Cincinnati, Ohio 2004

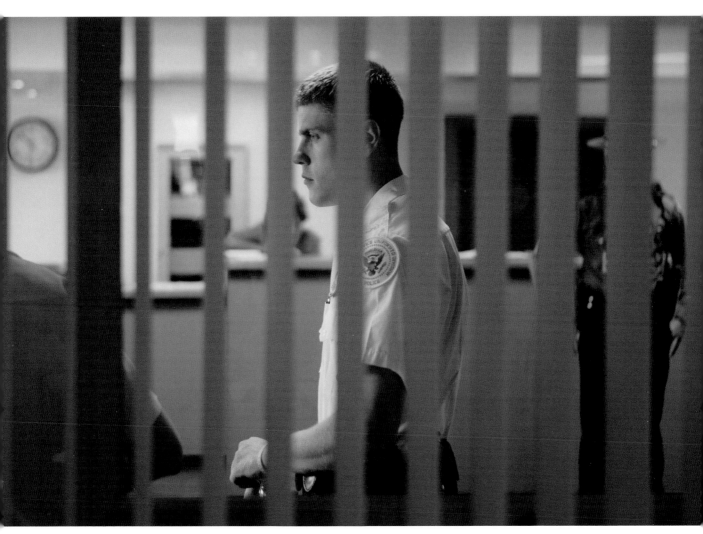

Columbus, Ohio 2005

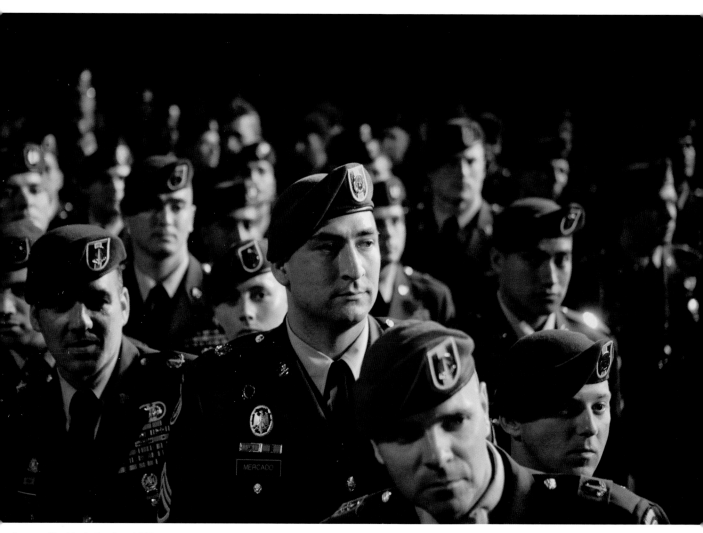

Fayetteville, North Carolina 2005

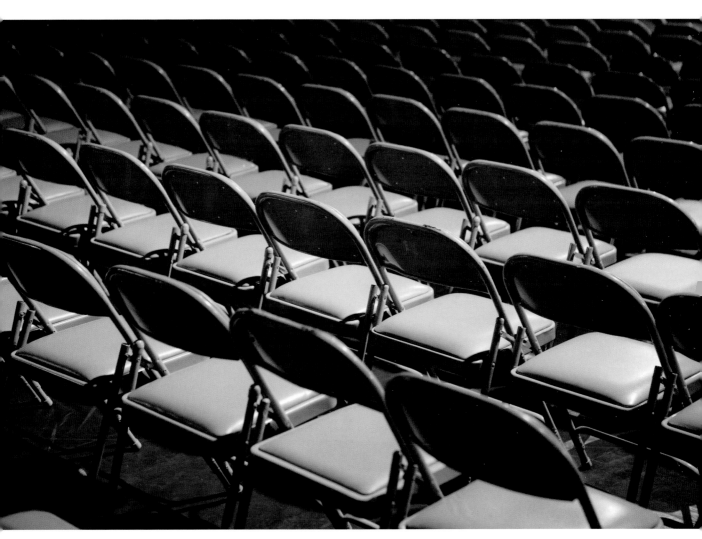

Fayetteville, North Carolina 2005

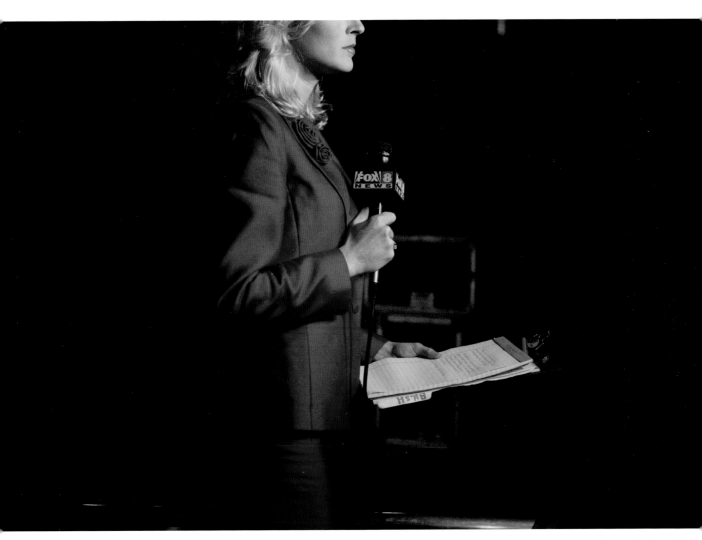

Fayetteville, North Carolina 2005

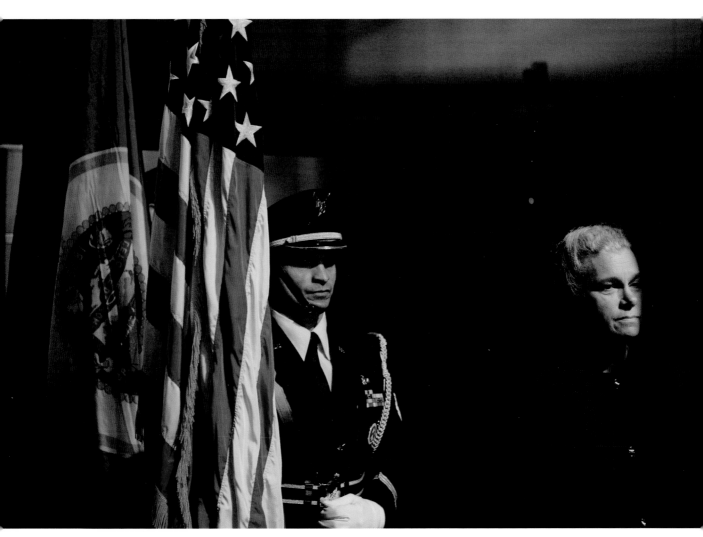

Fridley, Minnesota 2003

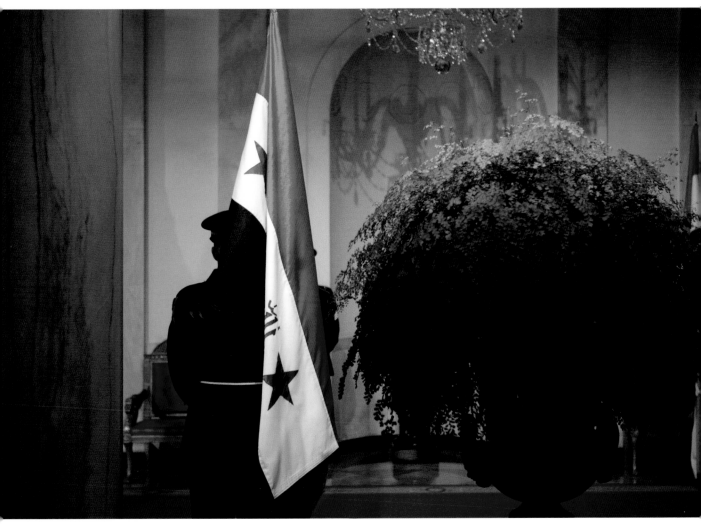

Washington, D.C. 2005

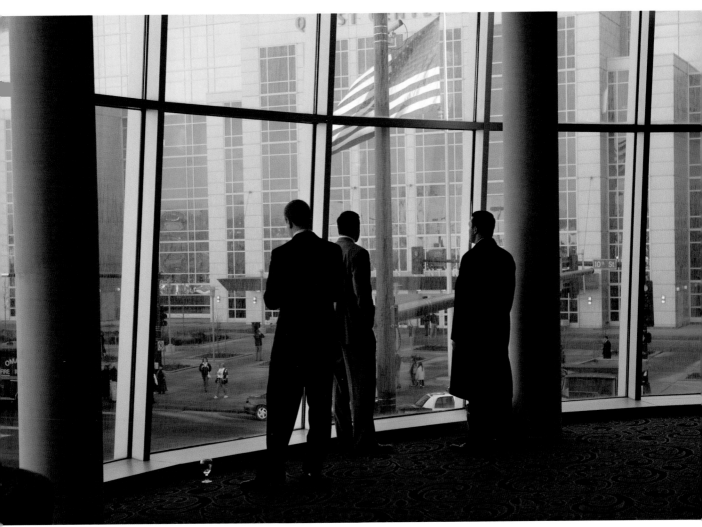

Omaha, Nebraska 2005

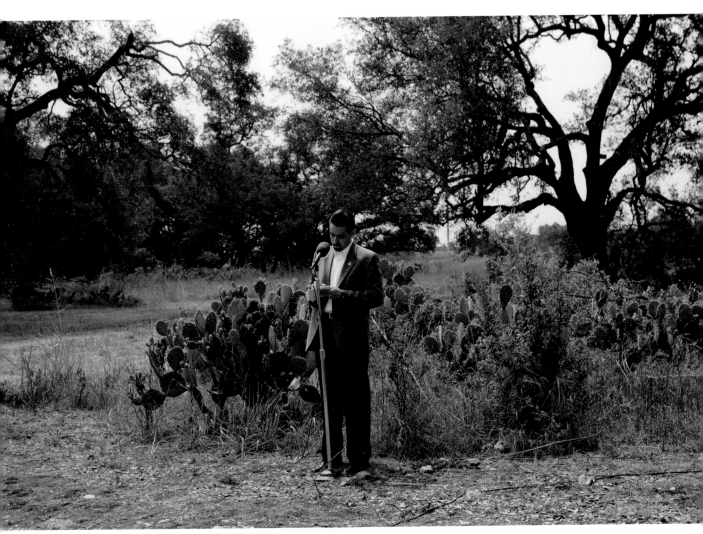

Crawford, Texas 2005

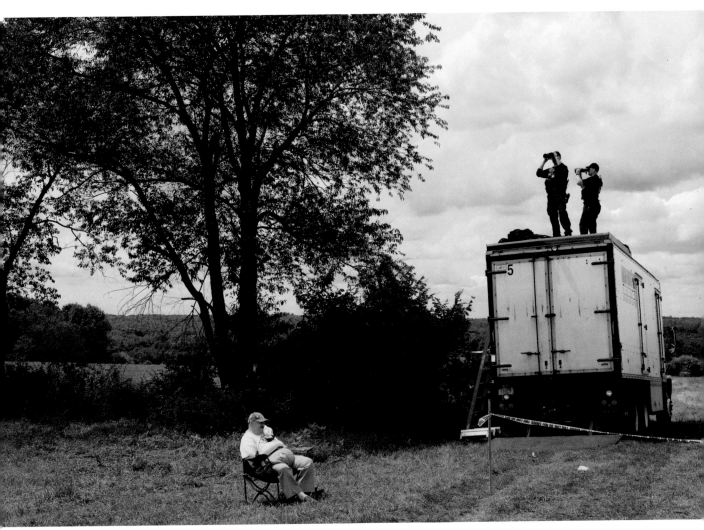

Stratham, New Hampshire 2004

Washington, D.C. 2005

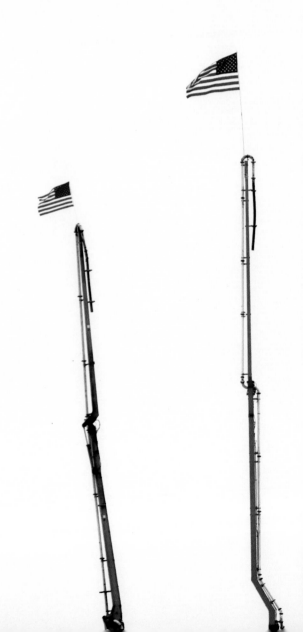

Springfield, Missouri 2004

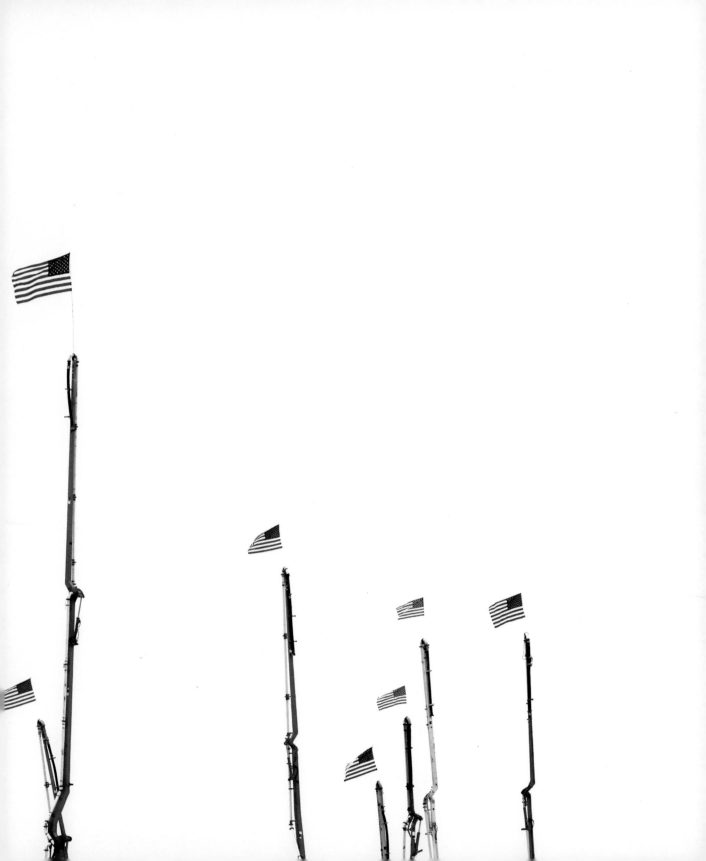

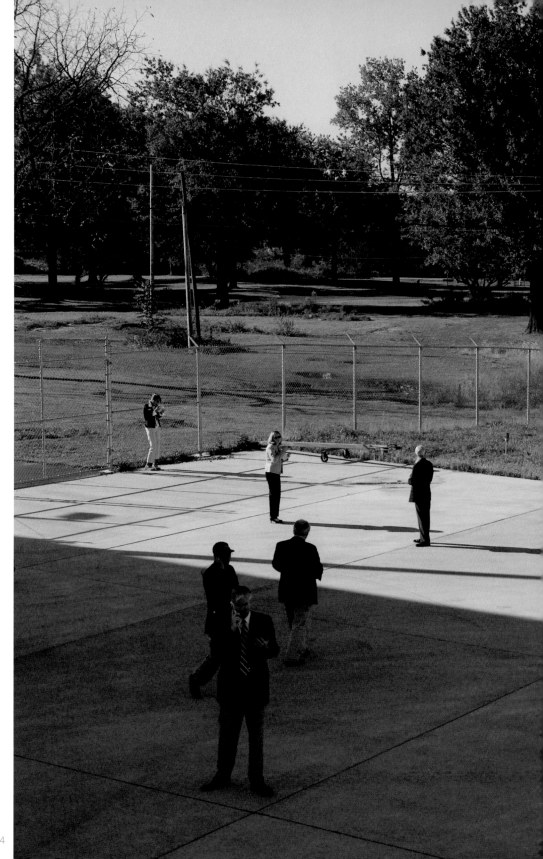

Manchester, New Hampshire 2004

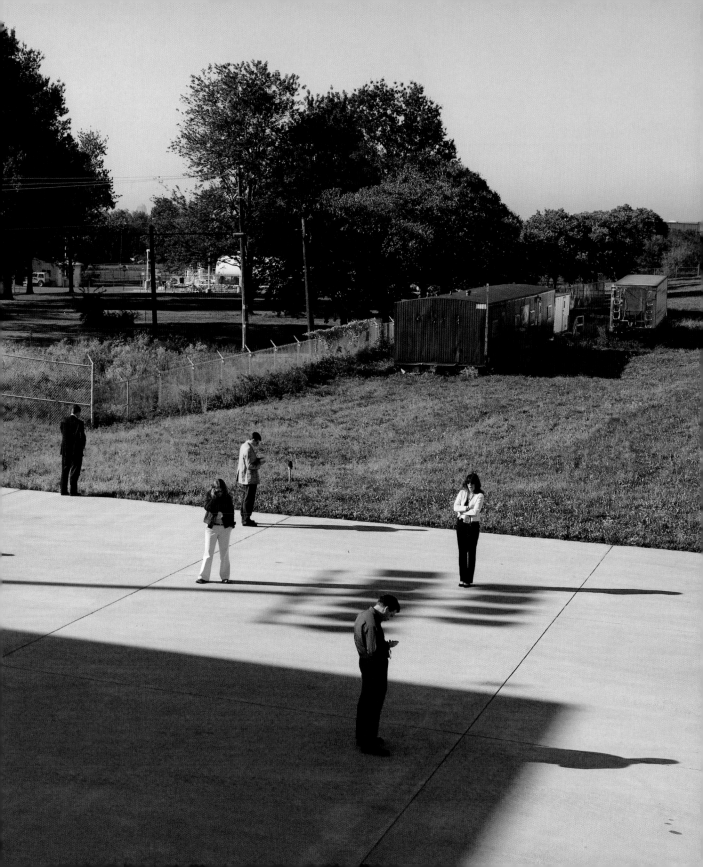

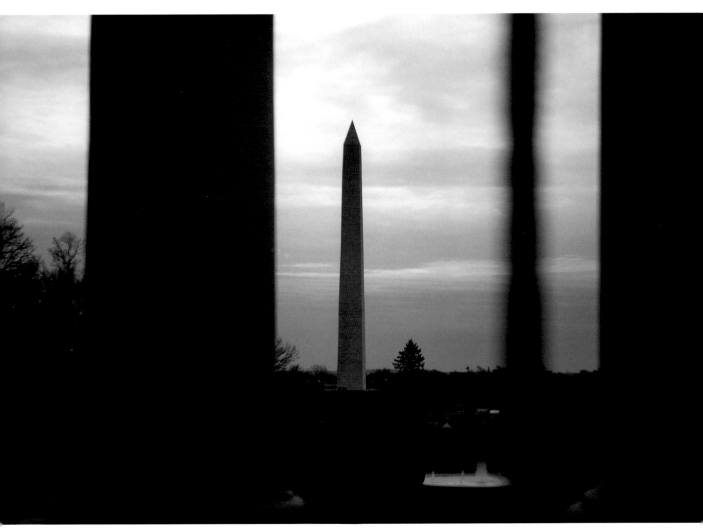

Washington, D.C. 2003

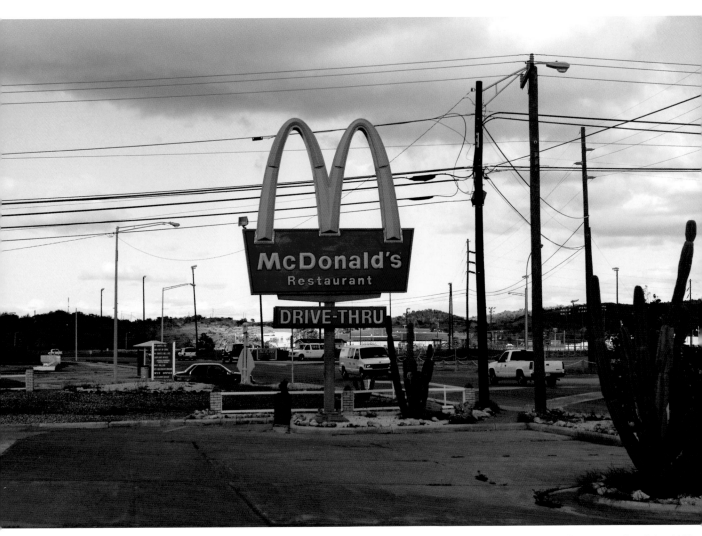

Guantanamo Bay, Cuba 2003

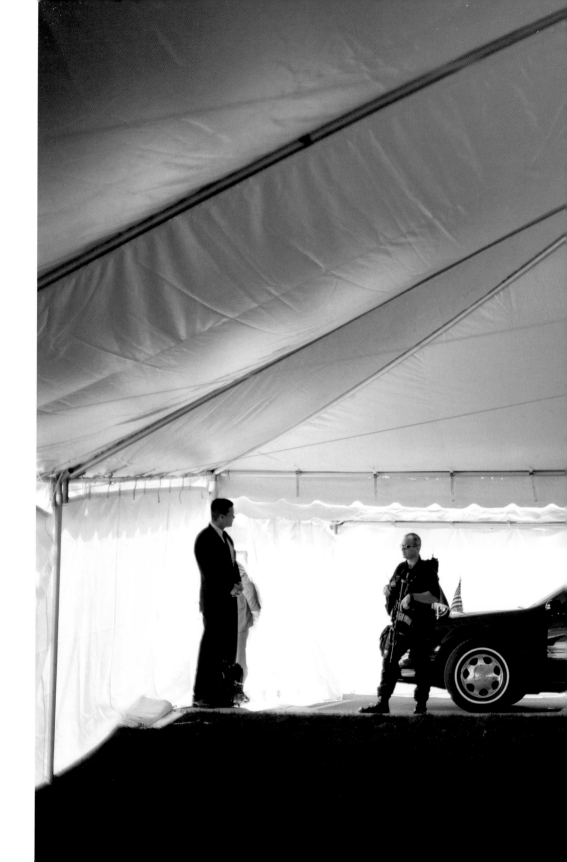

Traverse City, Michigan 2004

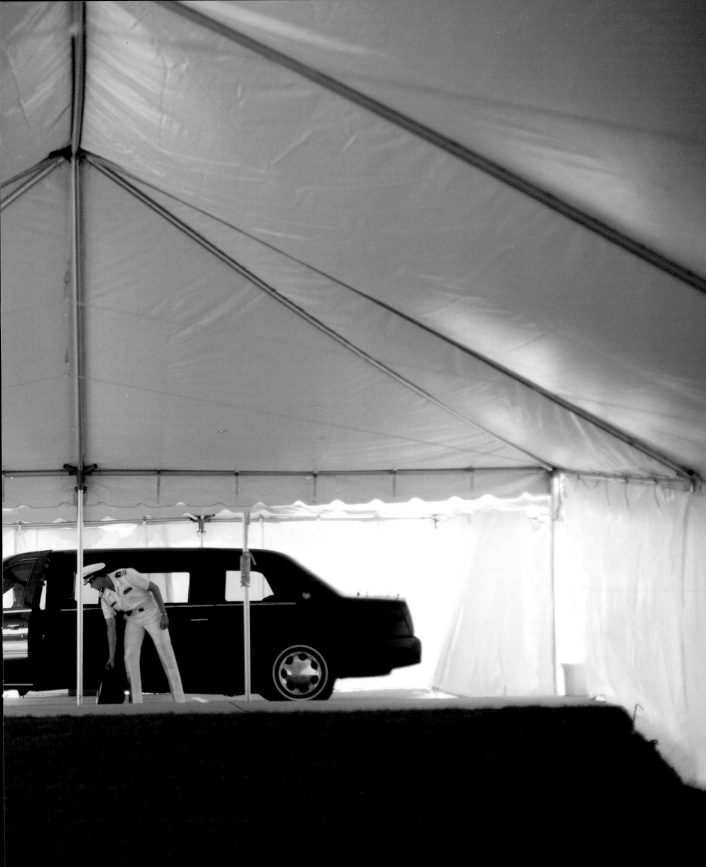

Hudson, Wisconsin 2004

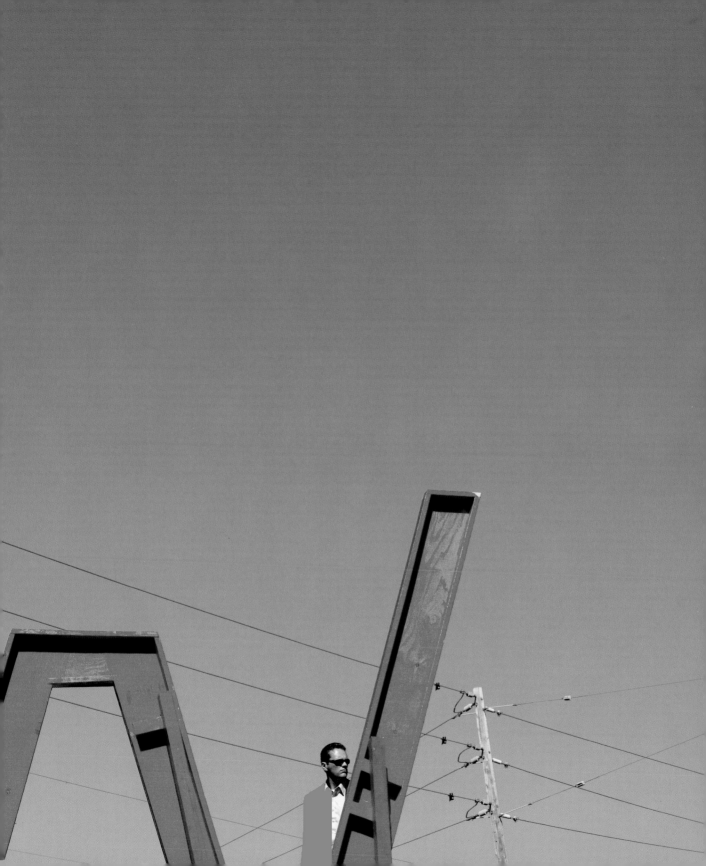

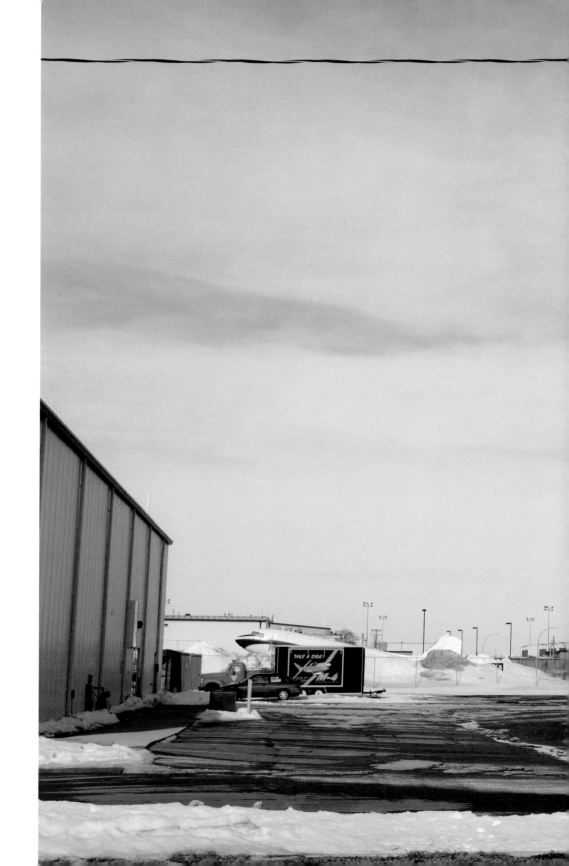

Fargo, North Dakota 2005

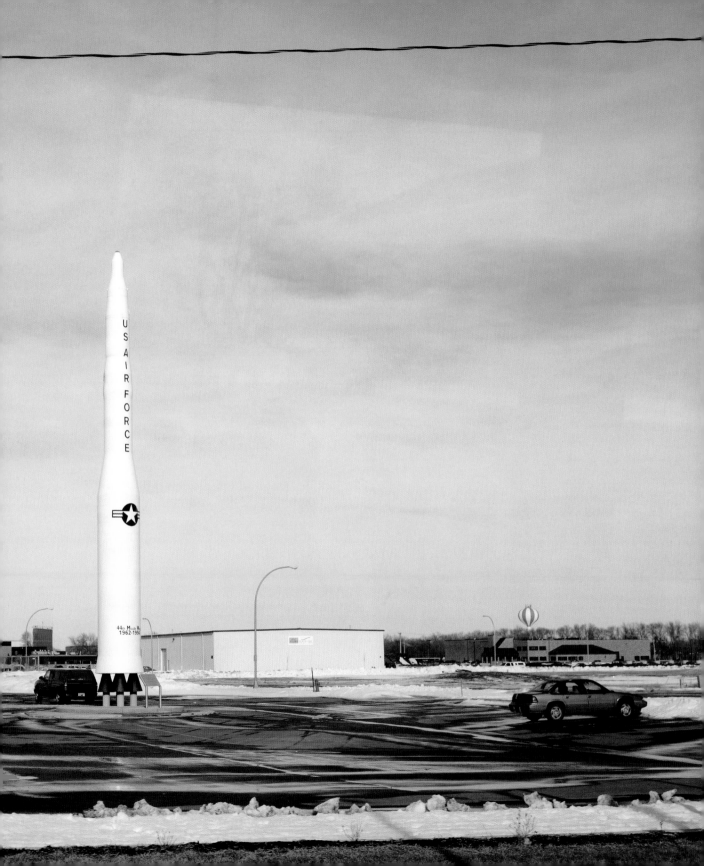

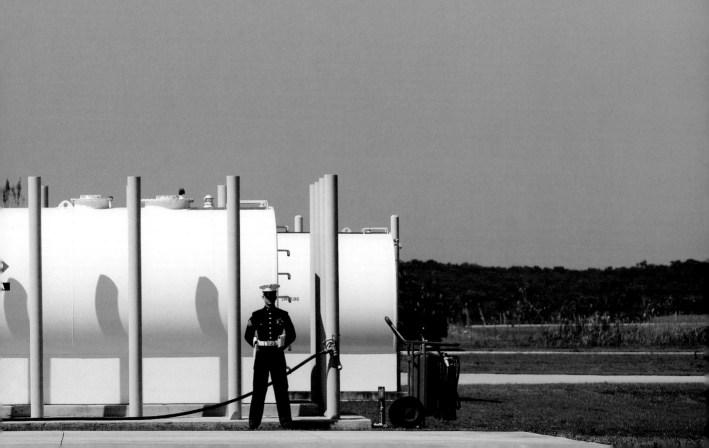

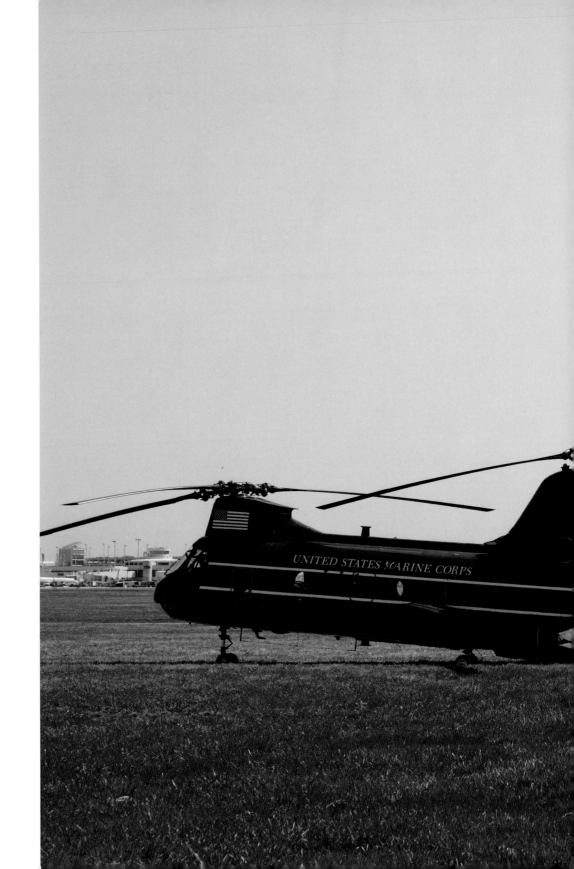

Killeen, Texas 2005

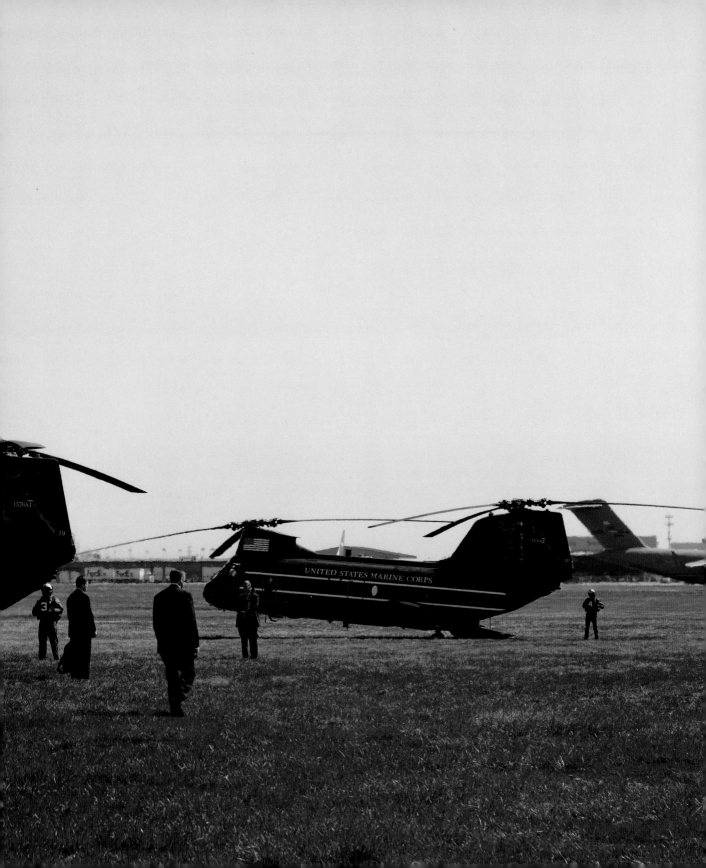

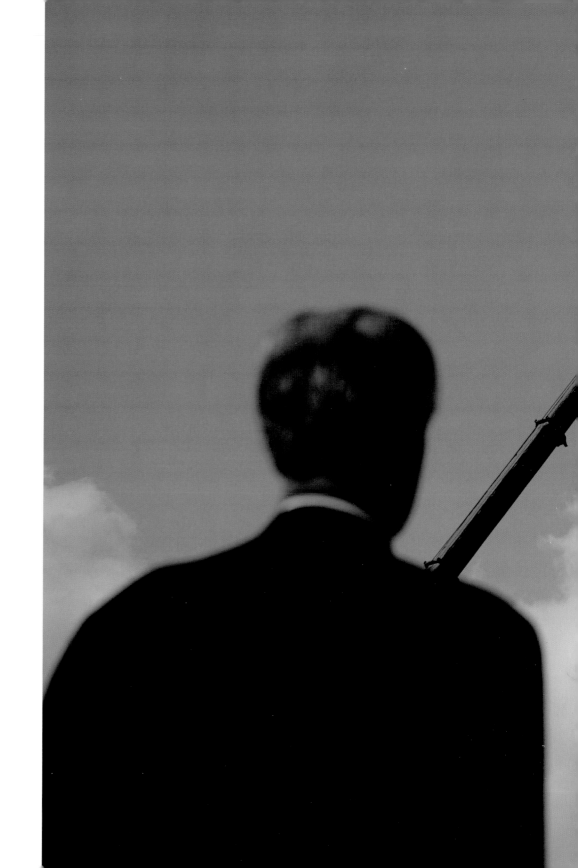

Cuyahoga Falls, Ohio 2004

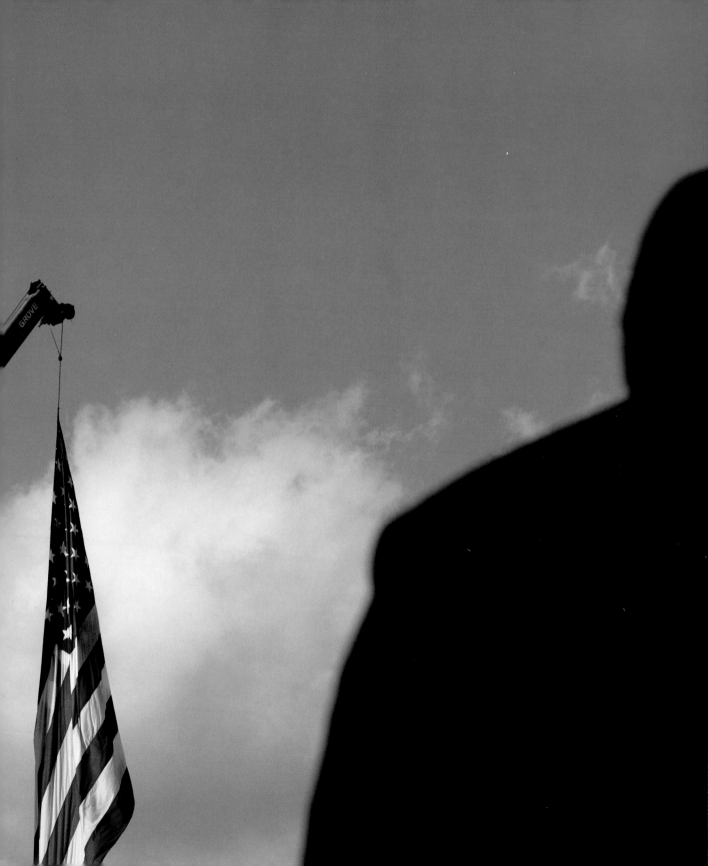

Sea Island, Georgia 2004

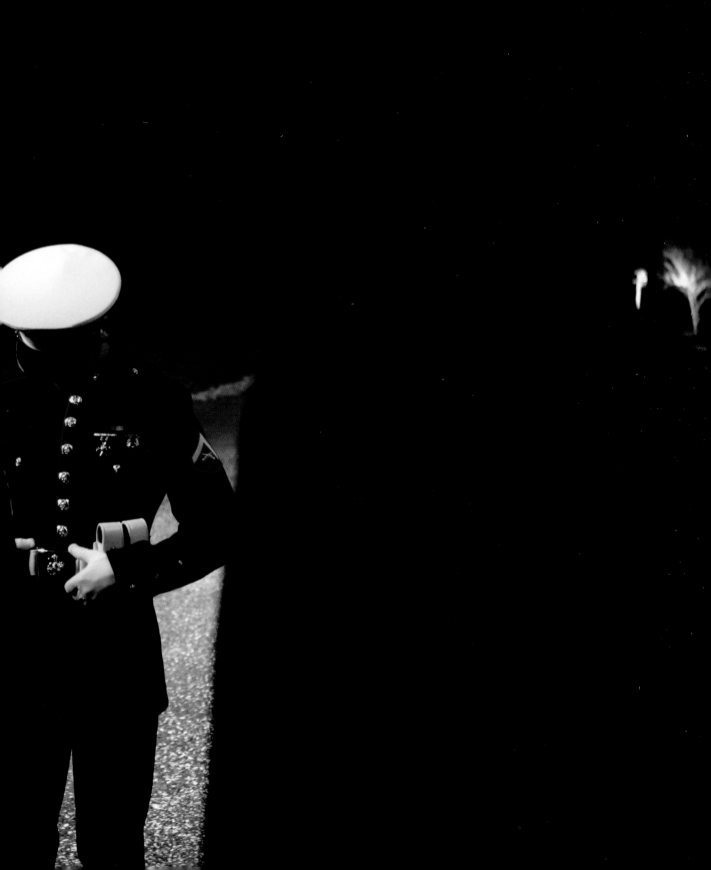

Washington, D.C. 2005

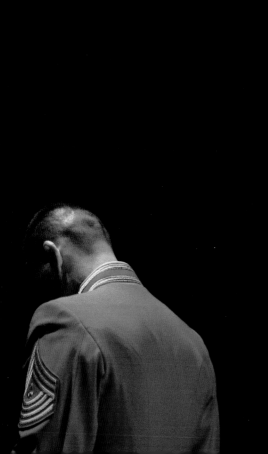

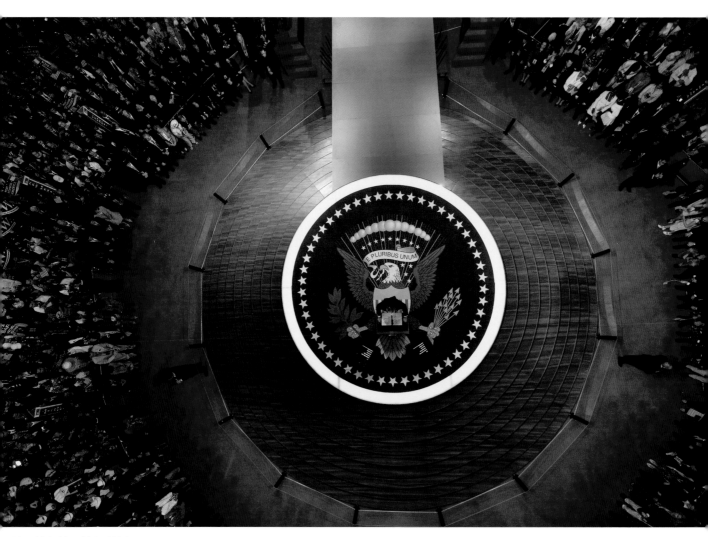

New York, New York 2004

Acknowledgments

All of this work was produced while on assignment for Time magazine.
Without the support of my editors, Michele Stephenson, MaryAnne Golon, Alice Gabriner,
Hillary Raskin and the entire photo staff at Time magazine, none of this photography would have
been possible. With special thanks to Alice, who early on in my project gave me guidance and
encouragement to continue.

Thanks to Howard Chapnick, Claudia Christen, Enrico Dagnino, Luc Delahaye, Frank Evers,
Mary Goldman, Sarah Hasted, Bill Hunt, Margaret Lafaro, Yukiko Launois, Jean-Francois Leroy,
Dave Metz, Grazia Neri, Robert Peacock, Gilles Peress, Charles Ommanney, Kathy Ryan,
Gerhard Steidl, Robert Stevens, Kenneth Troiano, Garrett White, all my colleagues at VII,
my mother and father, and my lovely wife Vesna.

Thank you.

First edition 2006

Photo editing by Christopher Morris and Claudia Christen
Book and jacket design by Claudia Christen
Produced by Garrett White, New York

Copyright © 2006 Christopher Morris for the photographs and text
Copyright © 2006 Steidl Publishers for this edition

Production and printing by Steidl, Göttingen, Germany

Steidl
Düstere Strasse 4
D-37073 Göttingen
Germany

Phone + 49 551 49 60 60
Fax + 49 551 49 60 649
Email mail@steidl.de
www.steidl.de
www.steidlville.com

ISBN 3-86521-201-8
ISBN 13: 978-3-86521-201-6

Printed in Germany